FRAGILE WORLD

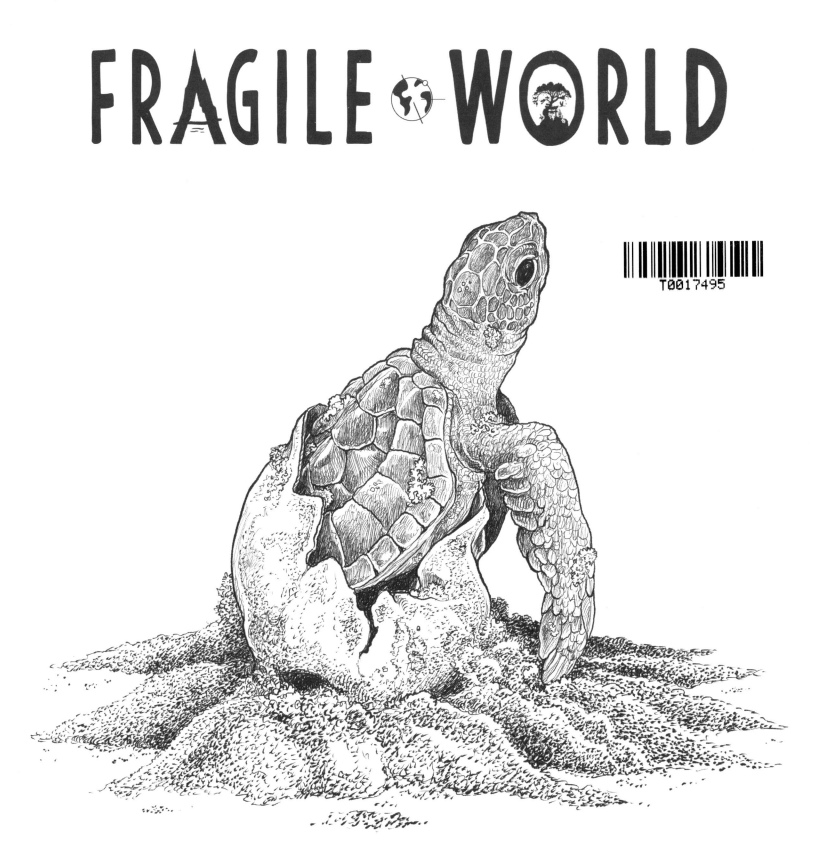

T0017495

PLUME

ILLUSTRATED BY
KERBY ROSANES

THIS BOOK BELONGS TO

..

Written and edited by Imogen Currell-Williams
Designed by Derrian Bradder
Cover design by John Bigwood

With thanks to Harry Thornton
for being a great talent scout

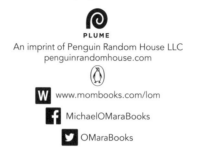

PLUME
An imprint of Penguin Random House LLC
penguinrandomhouse.com

www.mombooks.com/lom

MichaelOMaraBooks

OMaraBooks

ISBN 9780593183700

Printed in the United States of America
6th Printing

DISCOVER OUR FRAGILE WORLD IN THIS COLORING ADVENTURE.

Step into my high-definition, super-detailed world, where you will discover some of the most endangered and vulnerable animals in their natural habitats.

Each intricate illustration has been crafted with fineliner pens and can be colored in any way you like.

Find out more information about each animal at the back of the book.

Kerby Rosanes

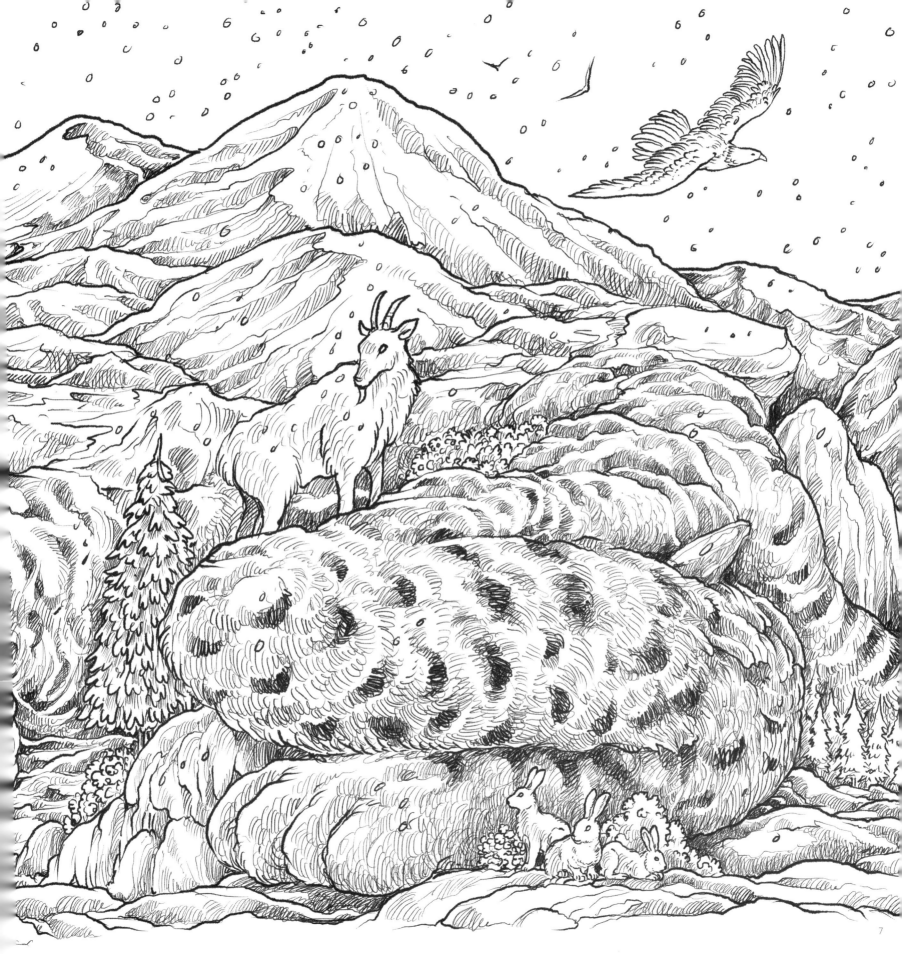

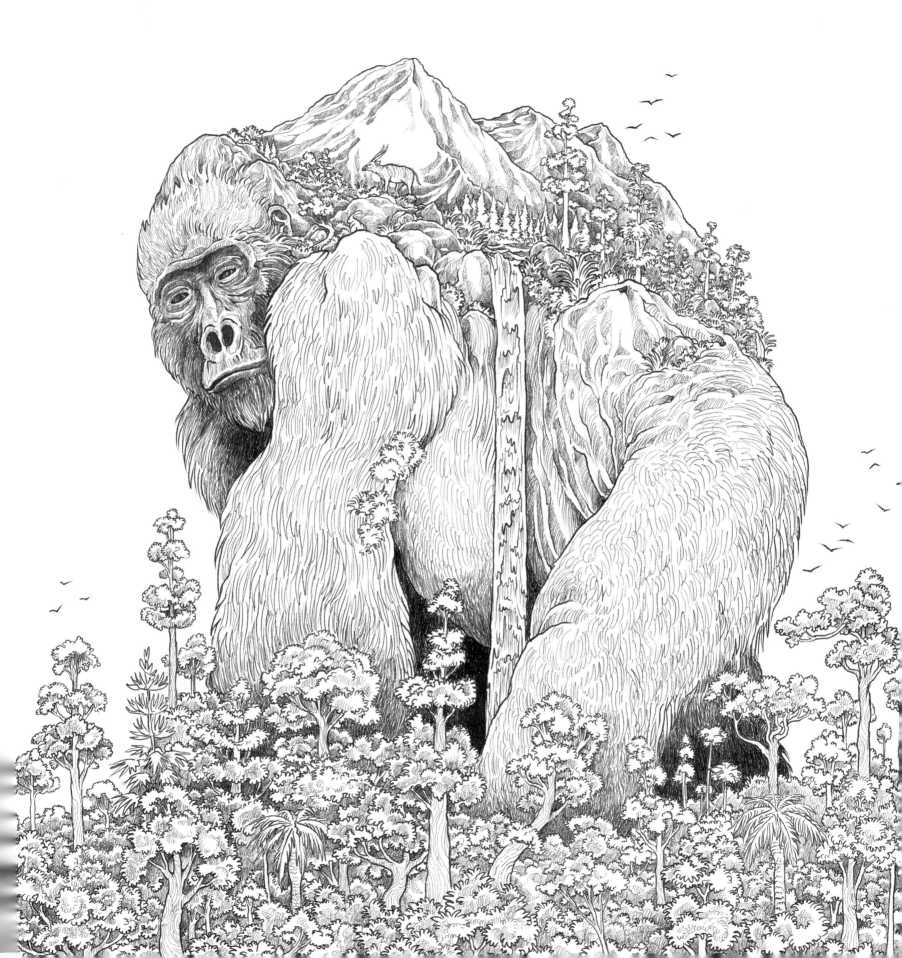

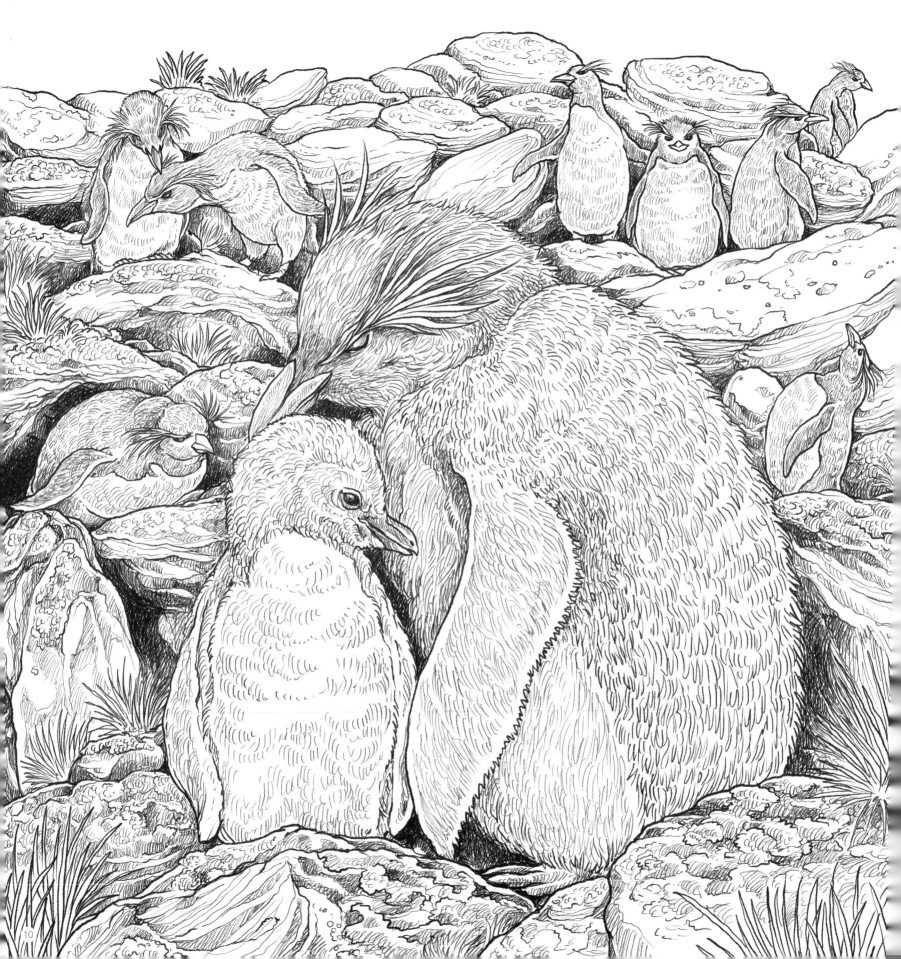

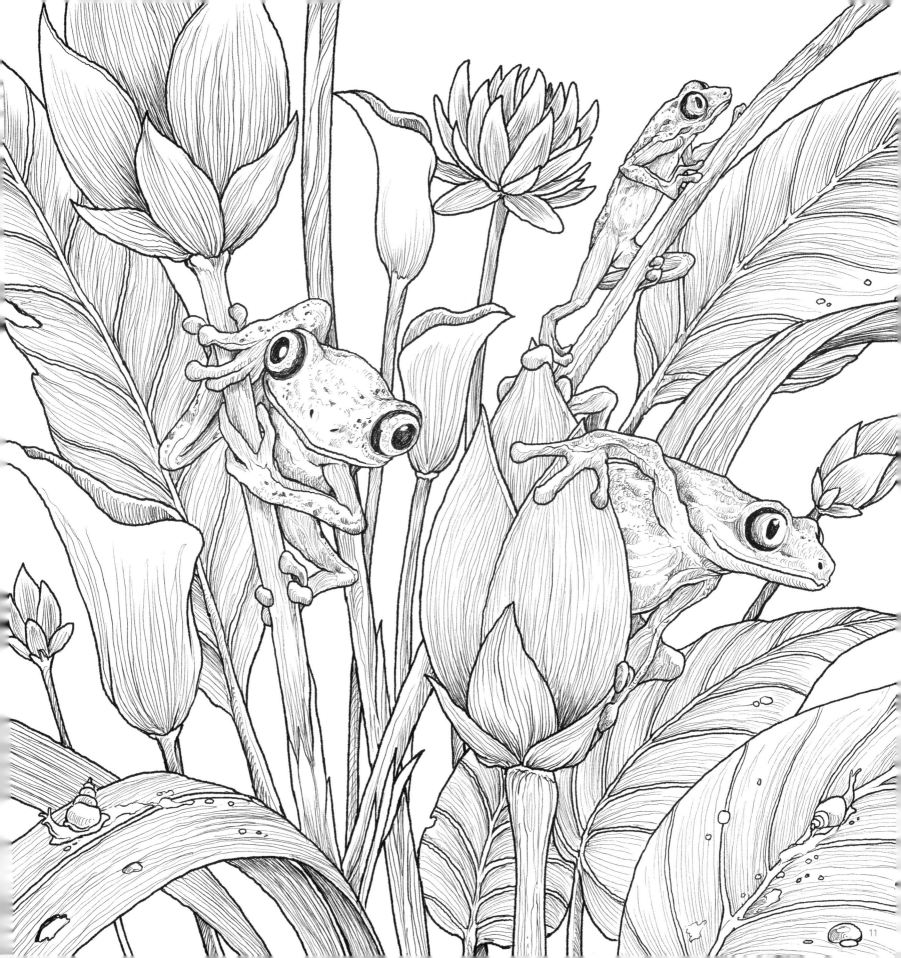

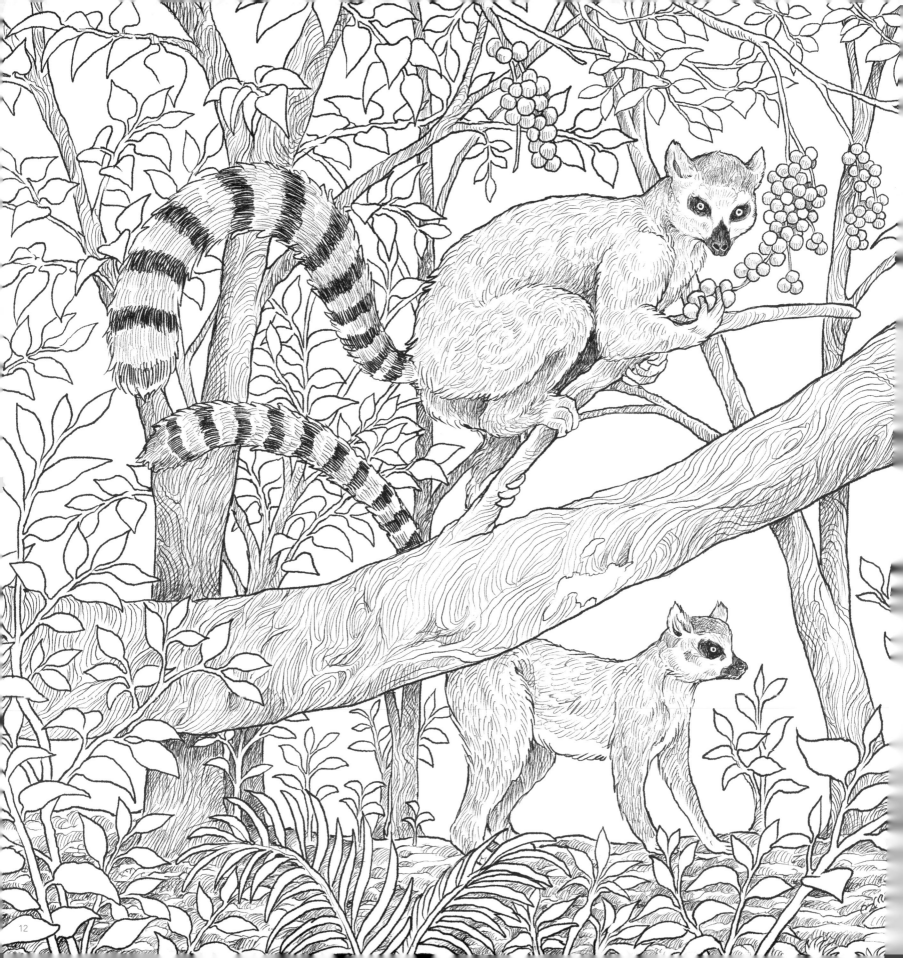

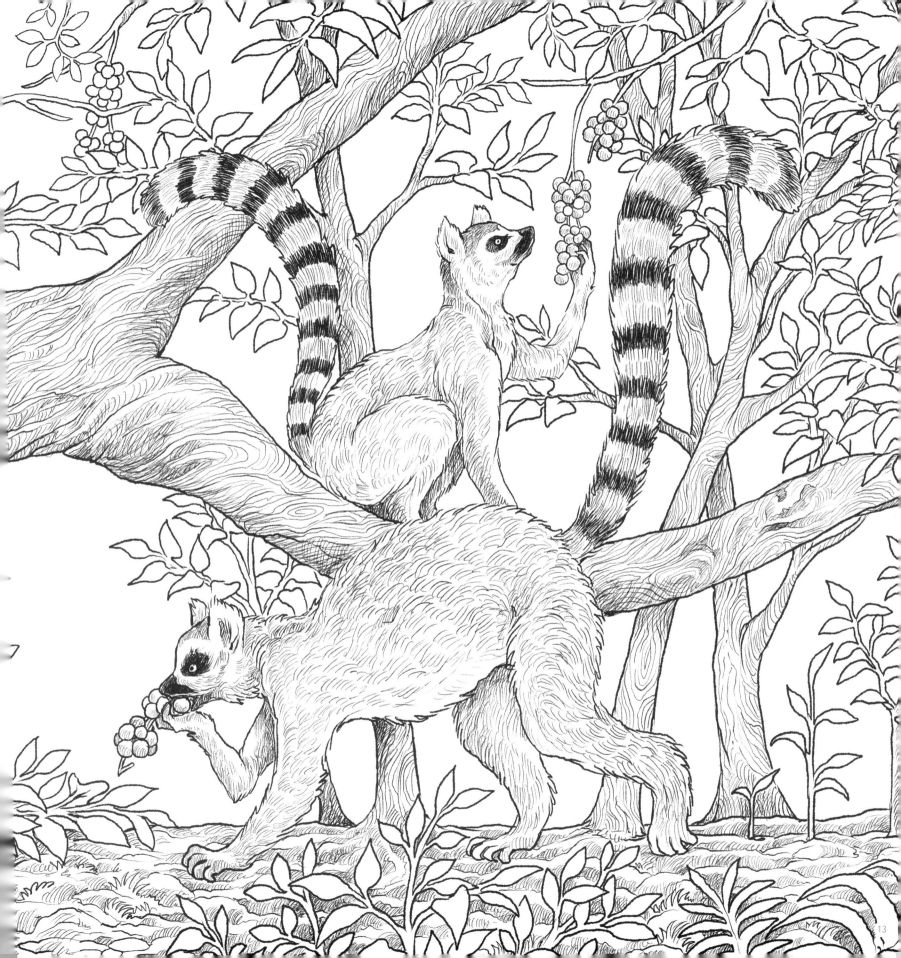

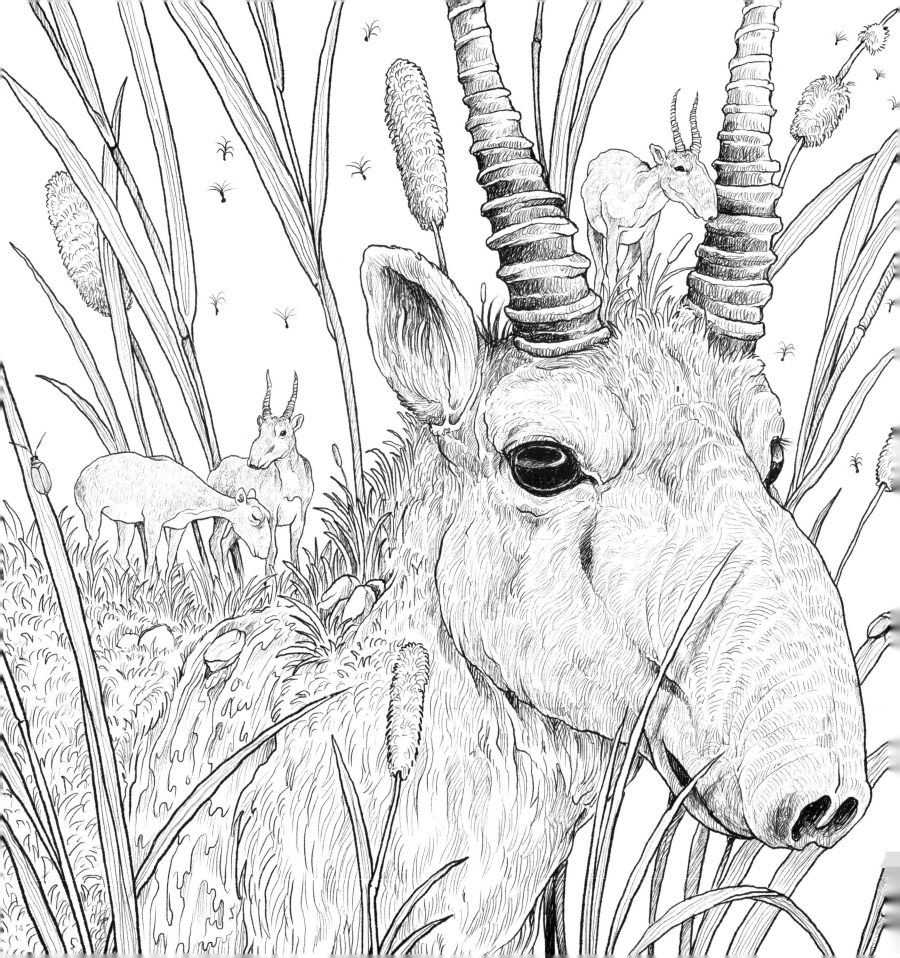

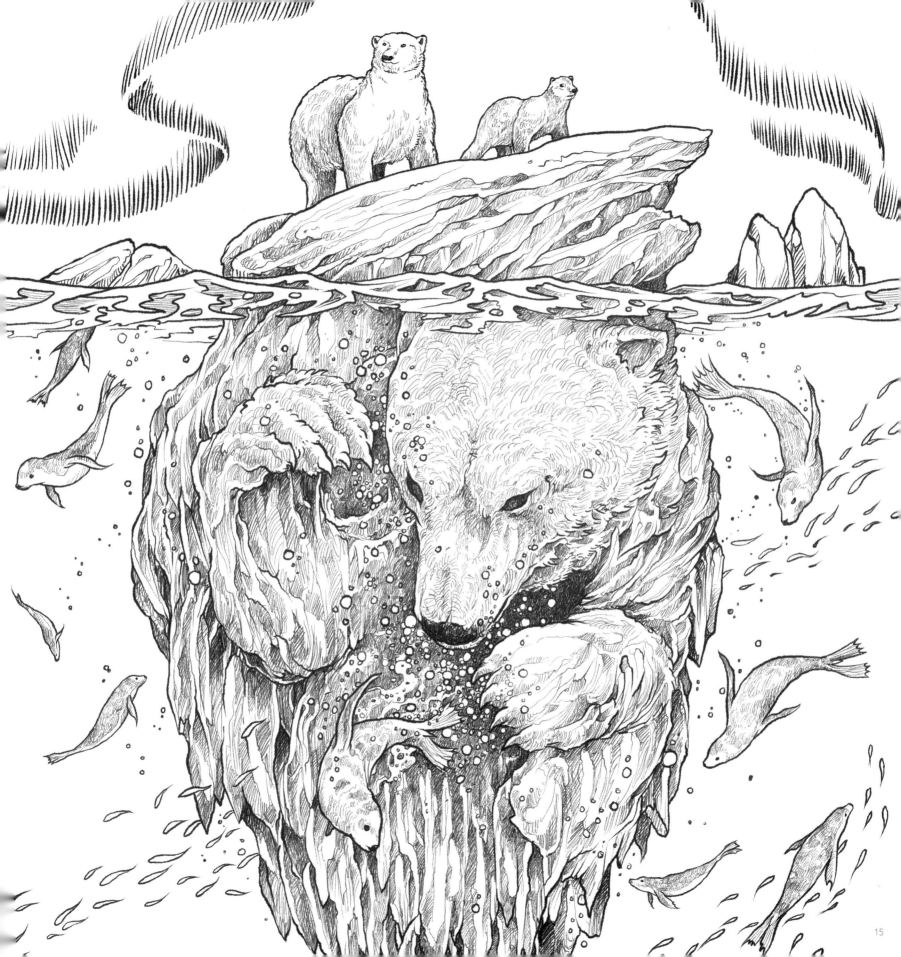

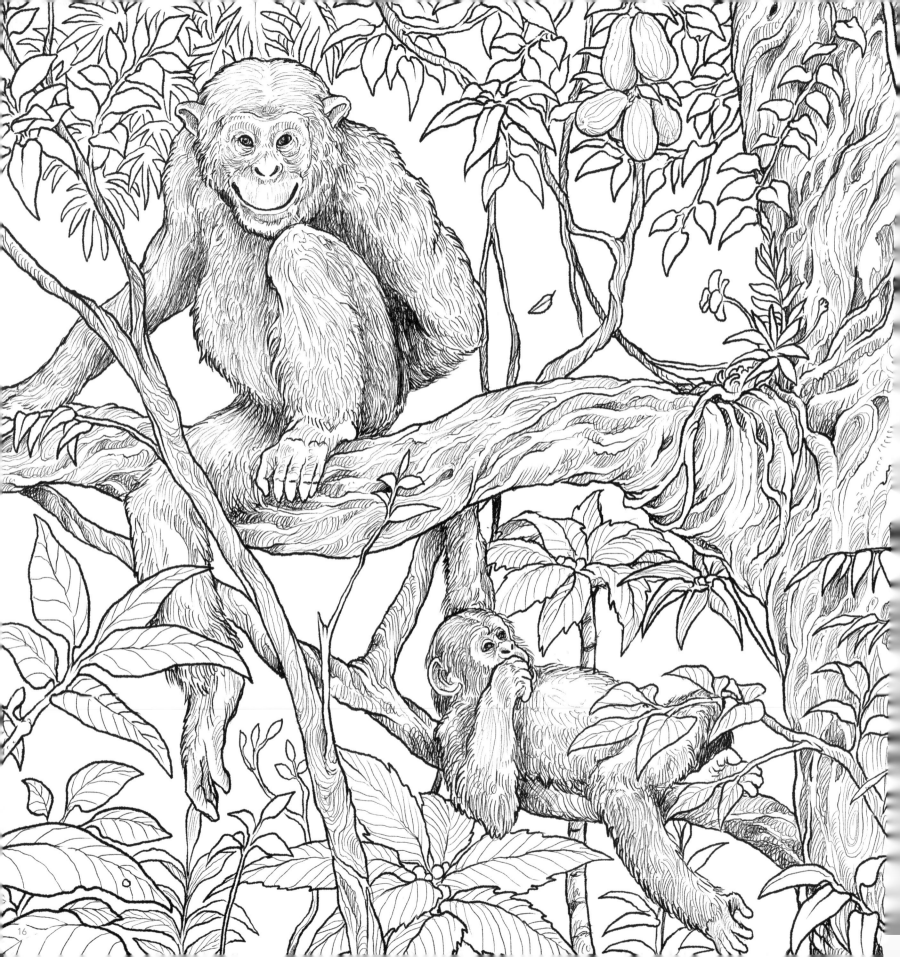

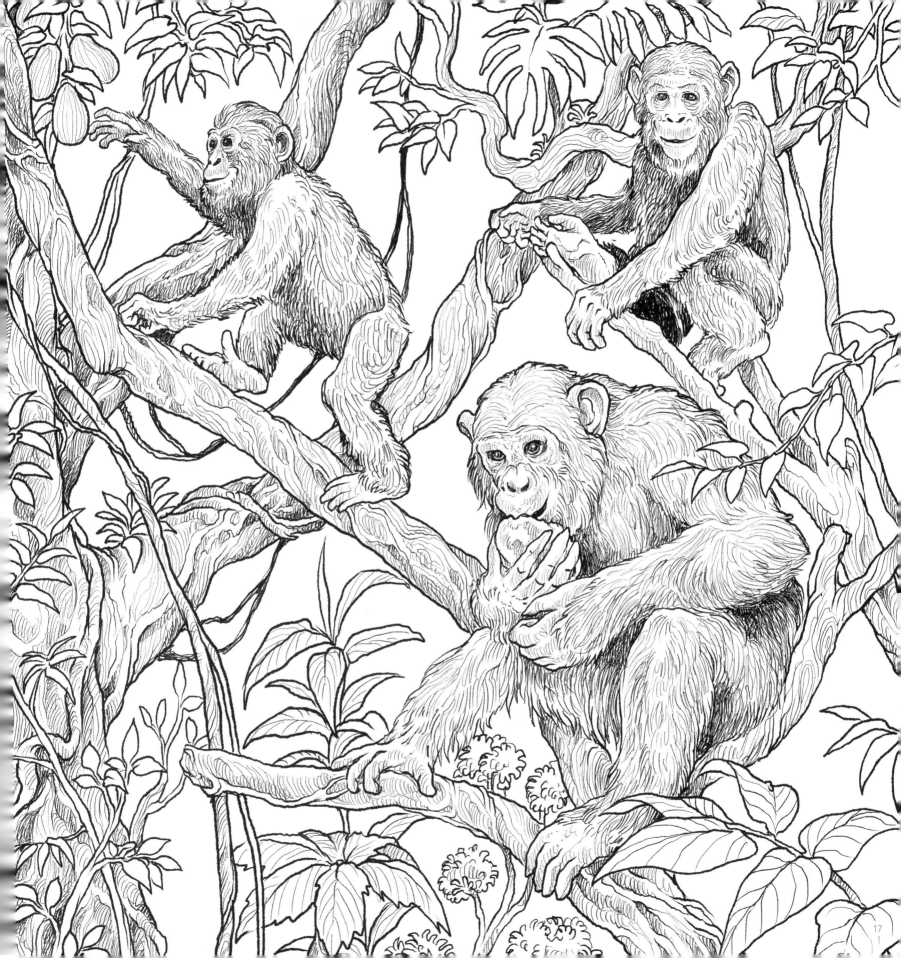

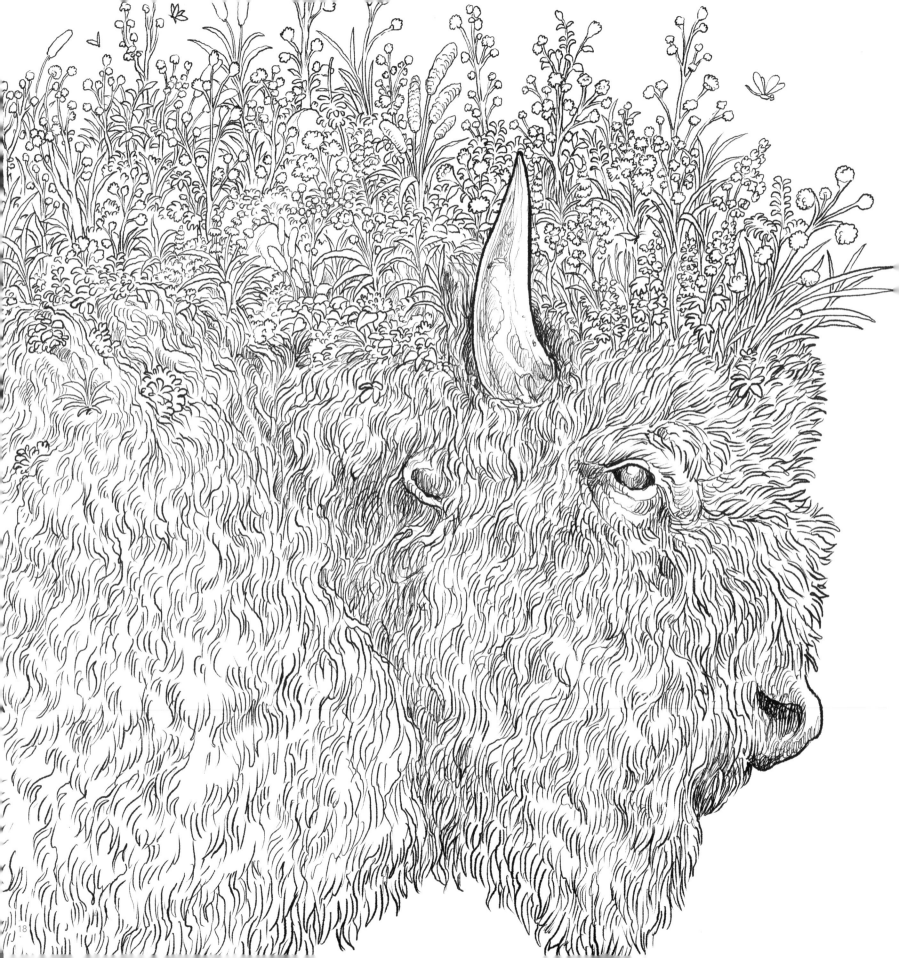

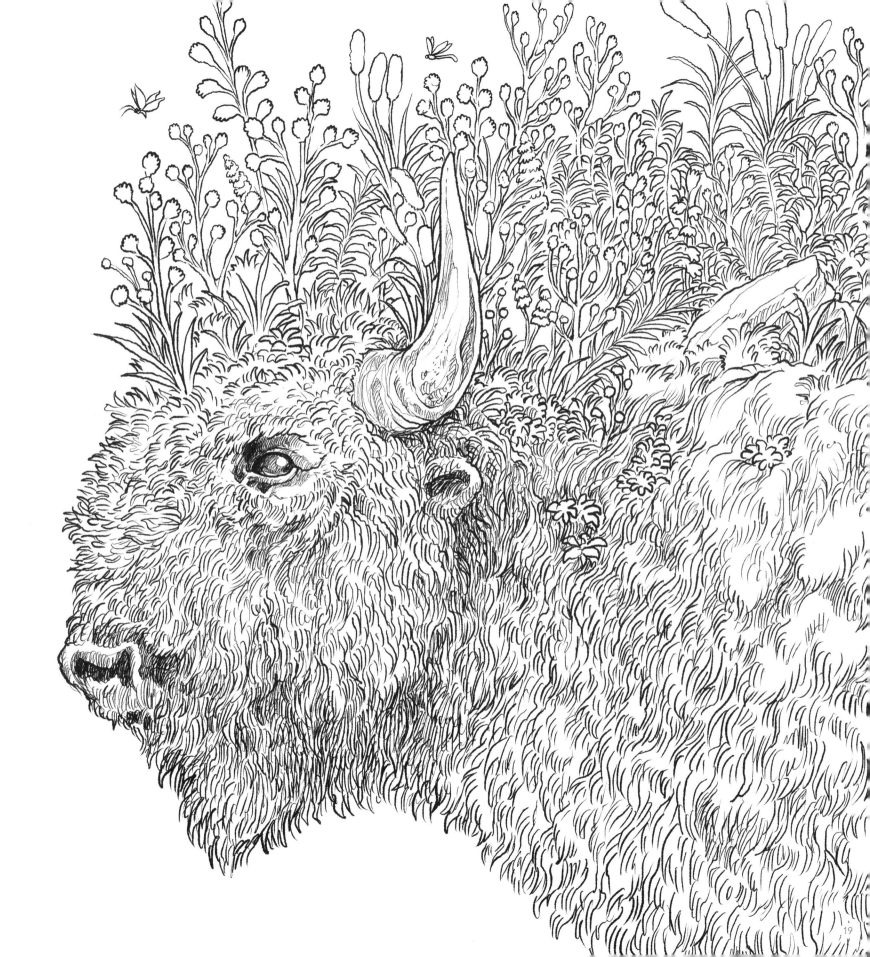

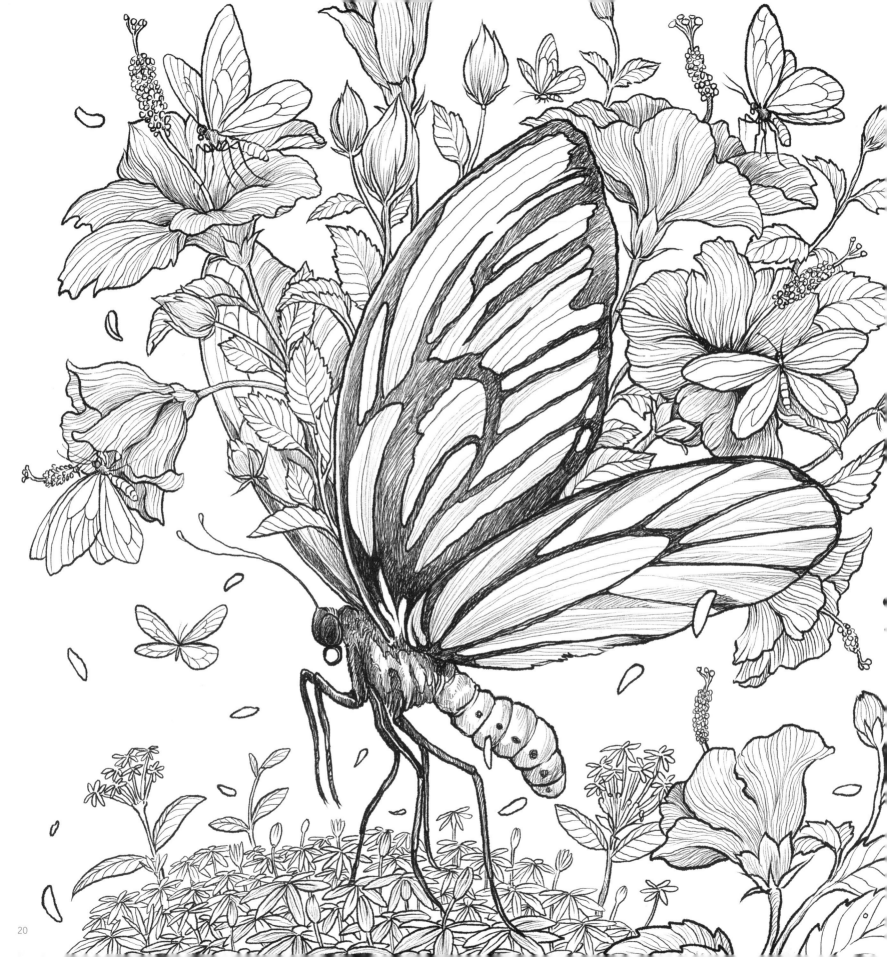

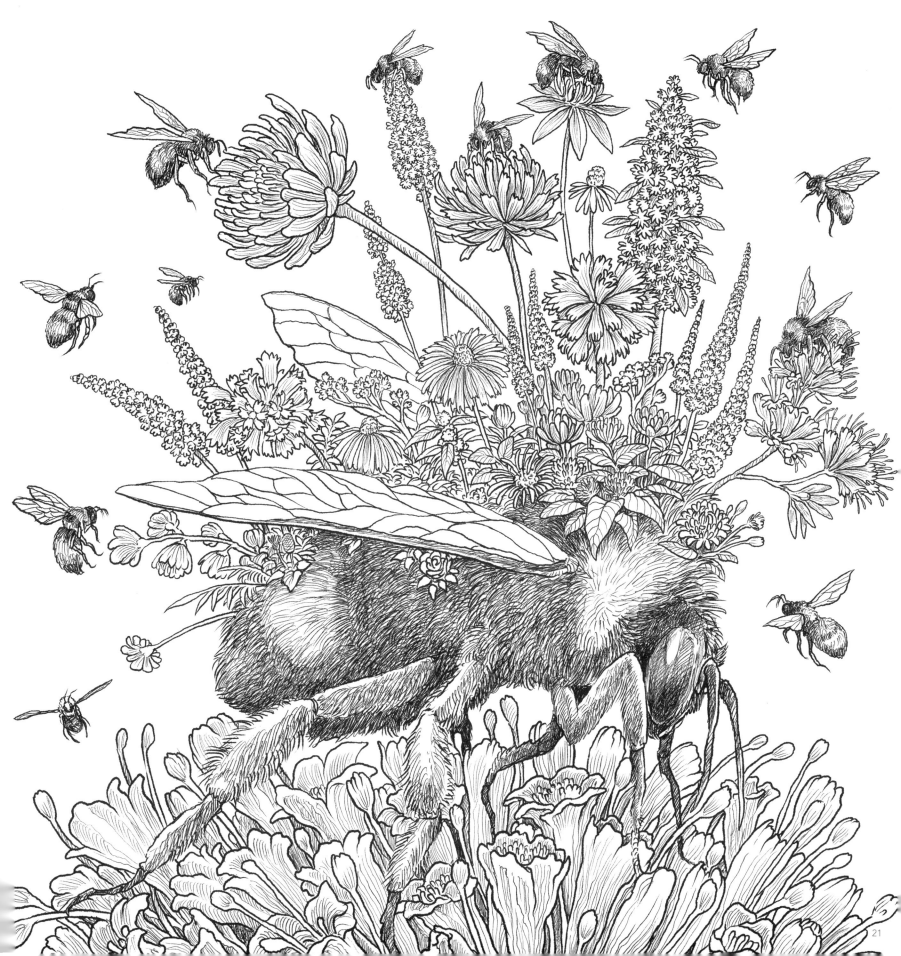

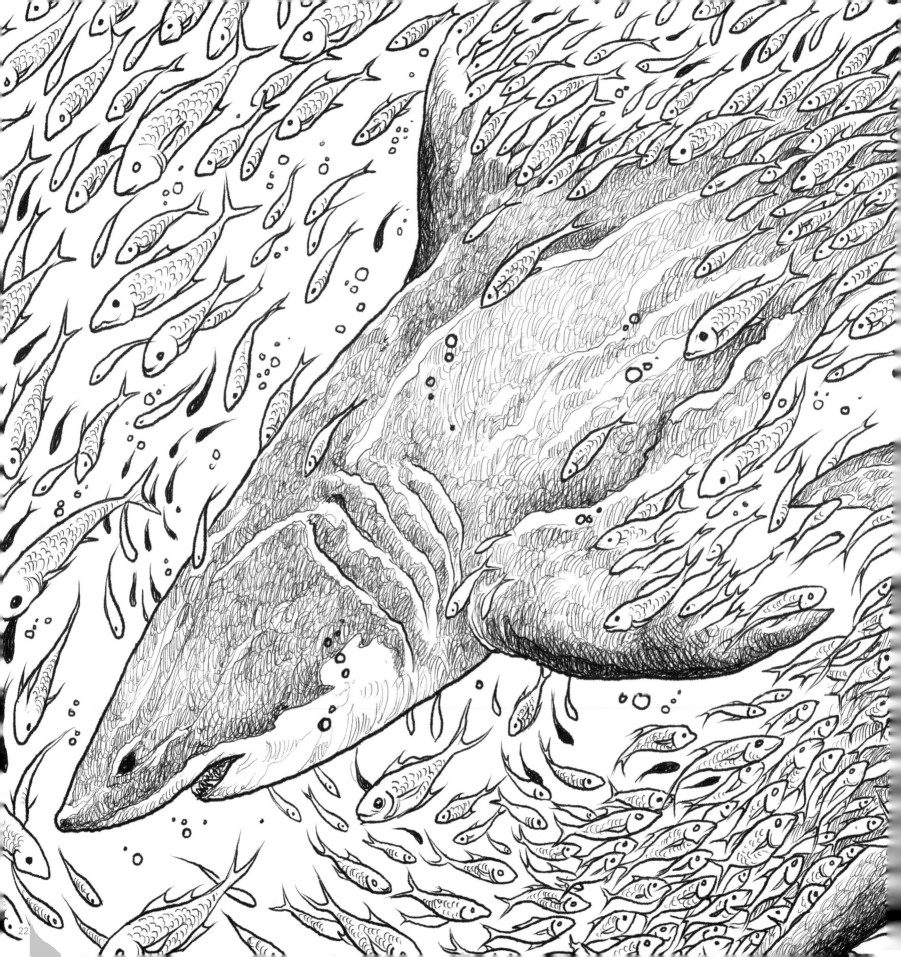

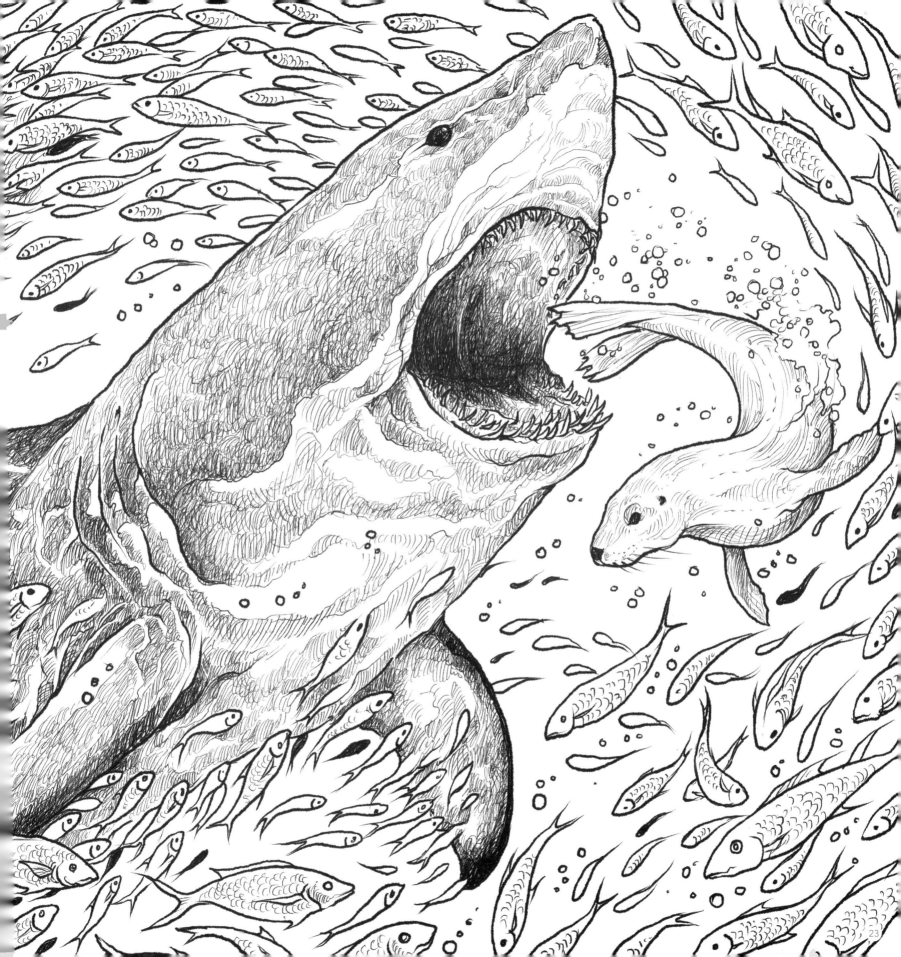

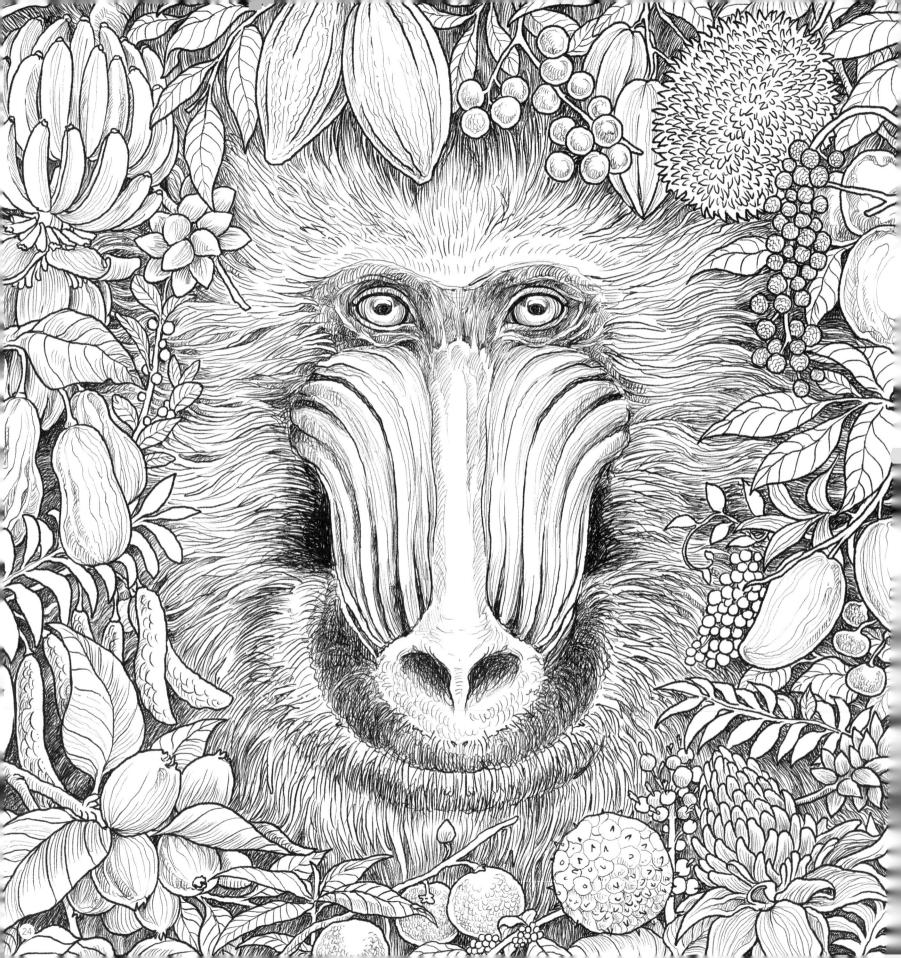

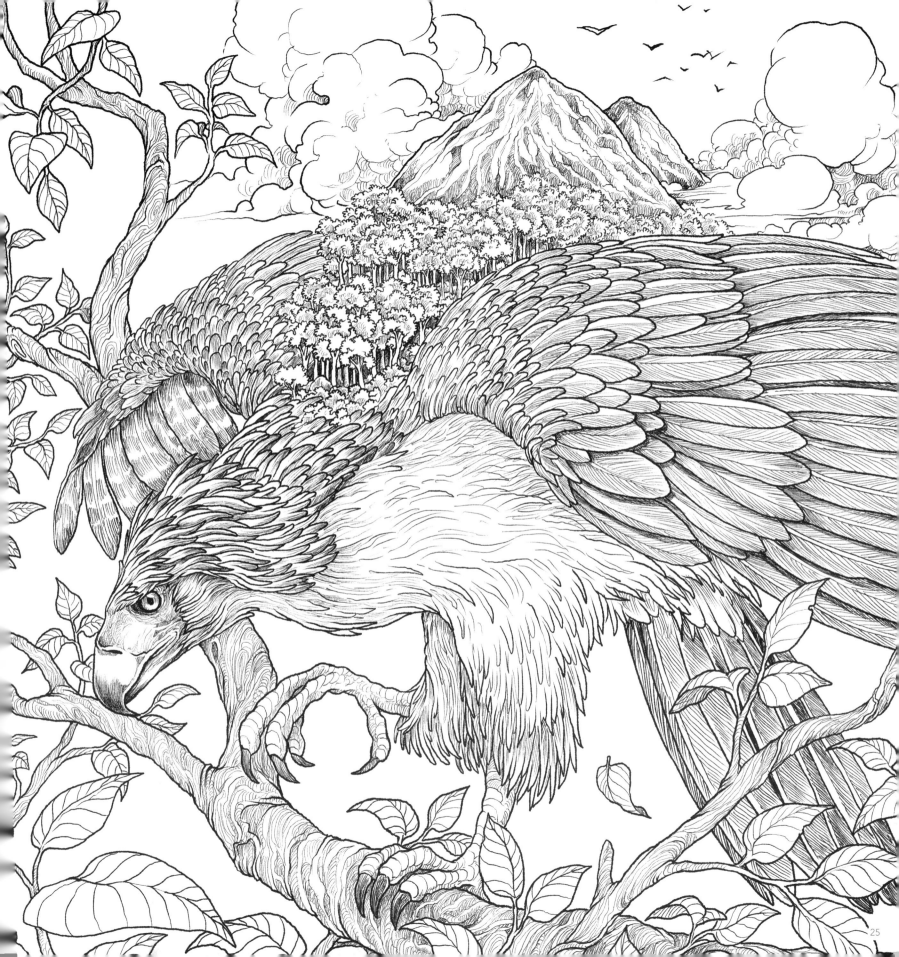

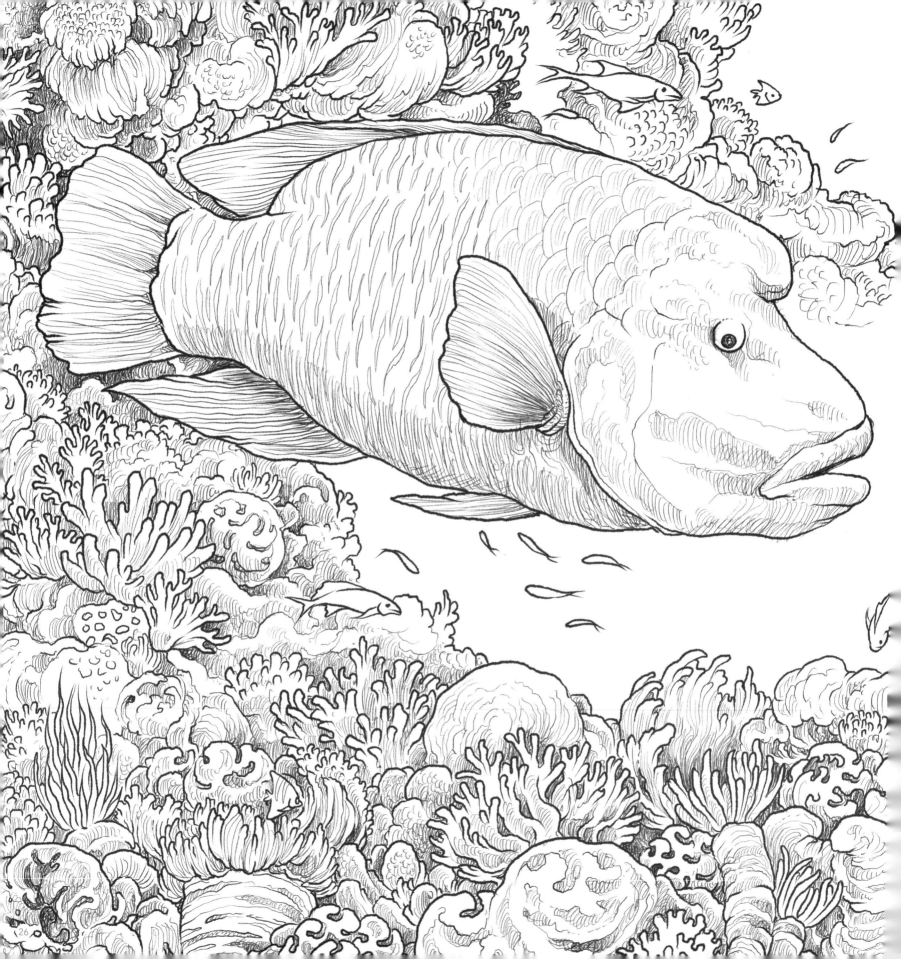

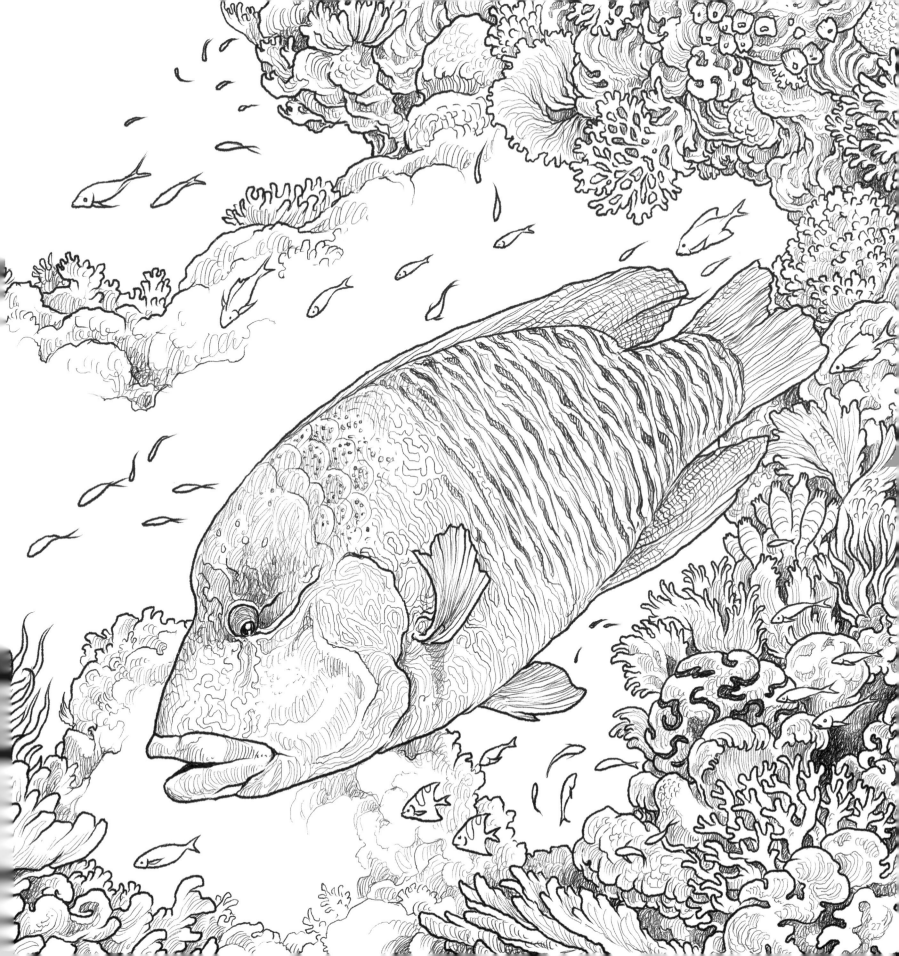

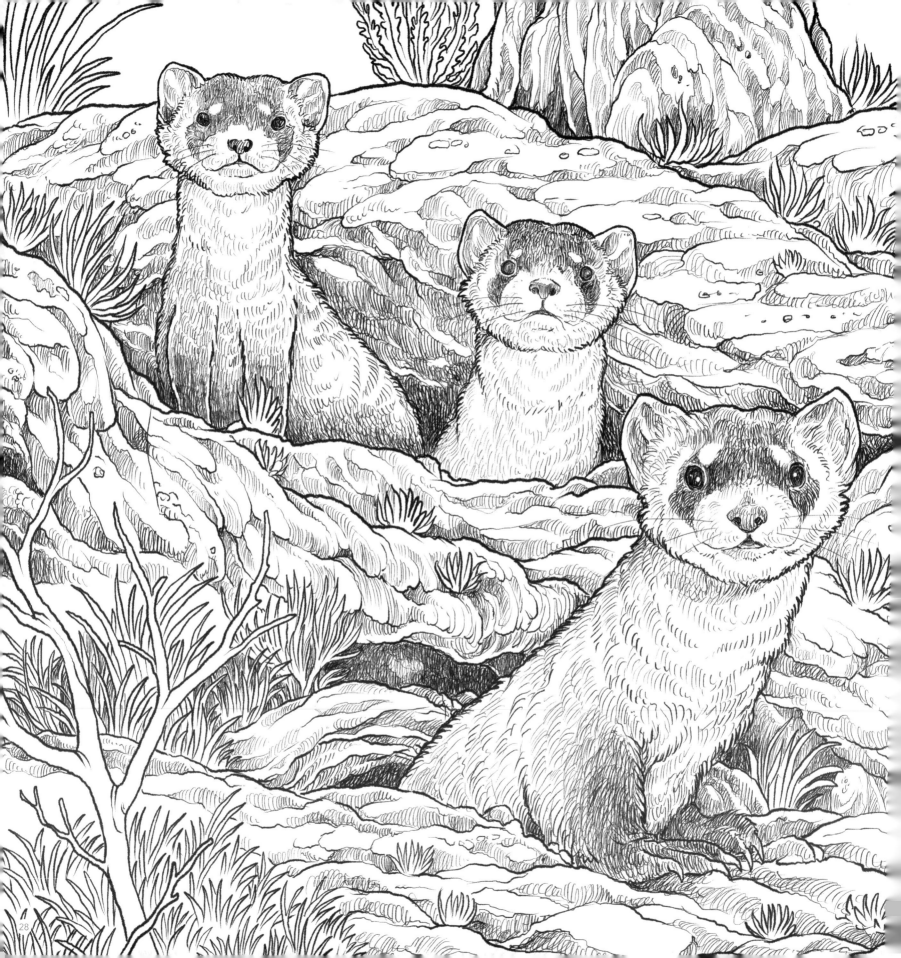

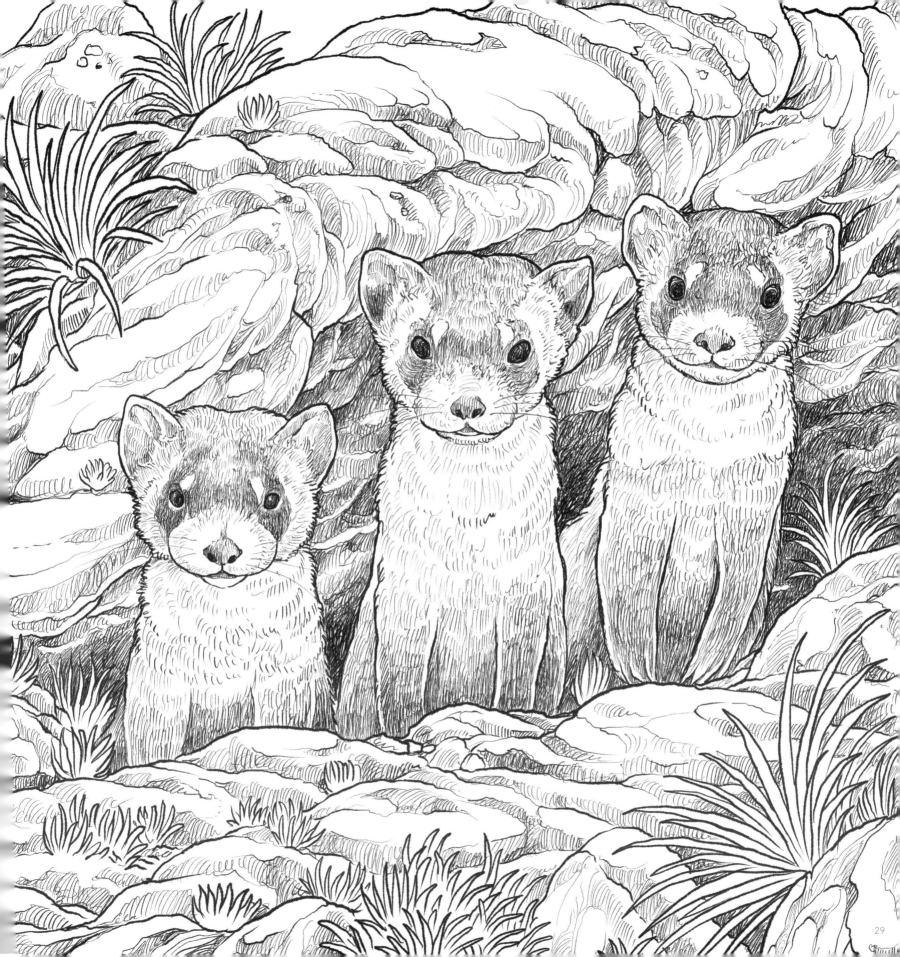

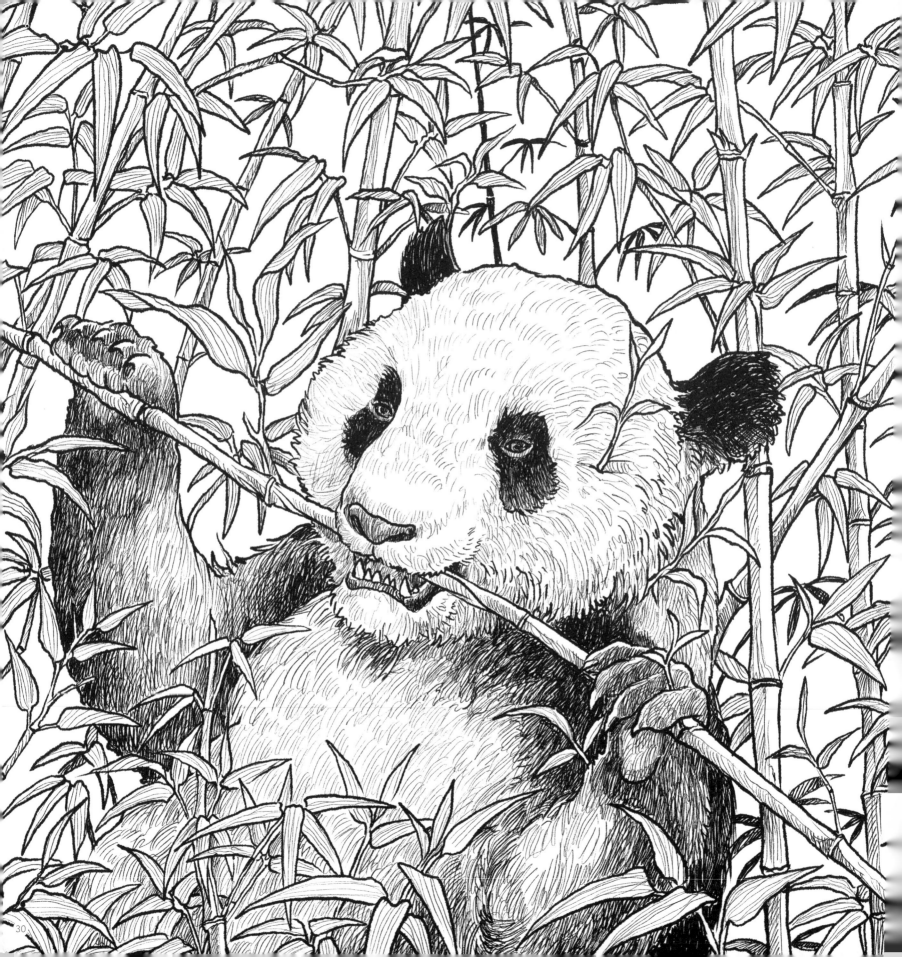

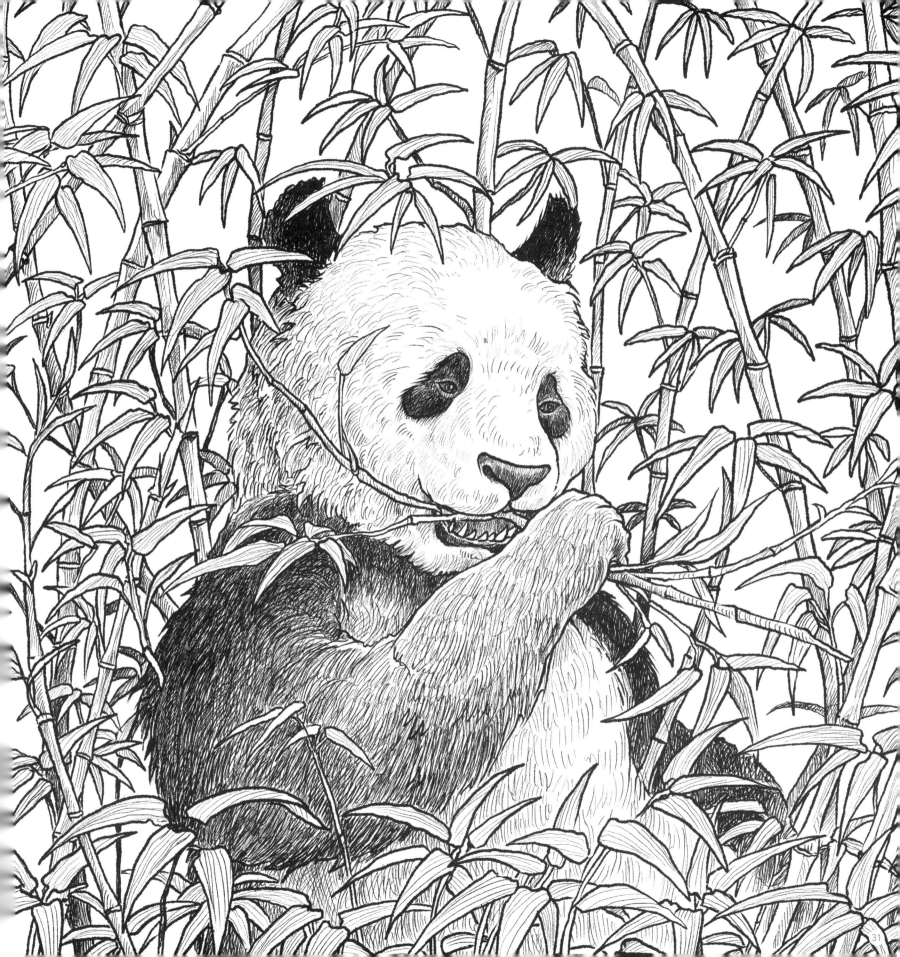

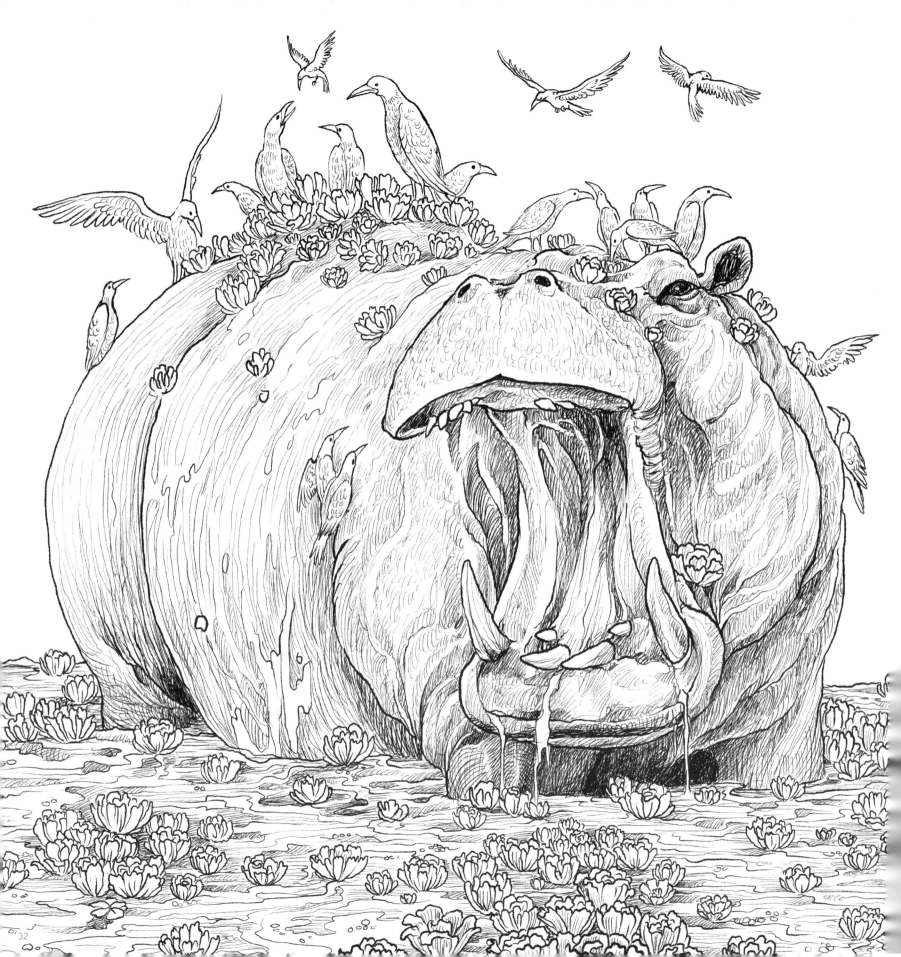

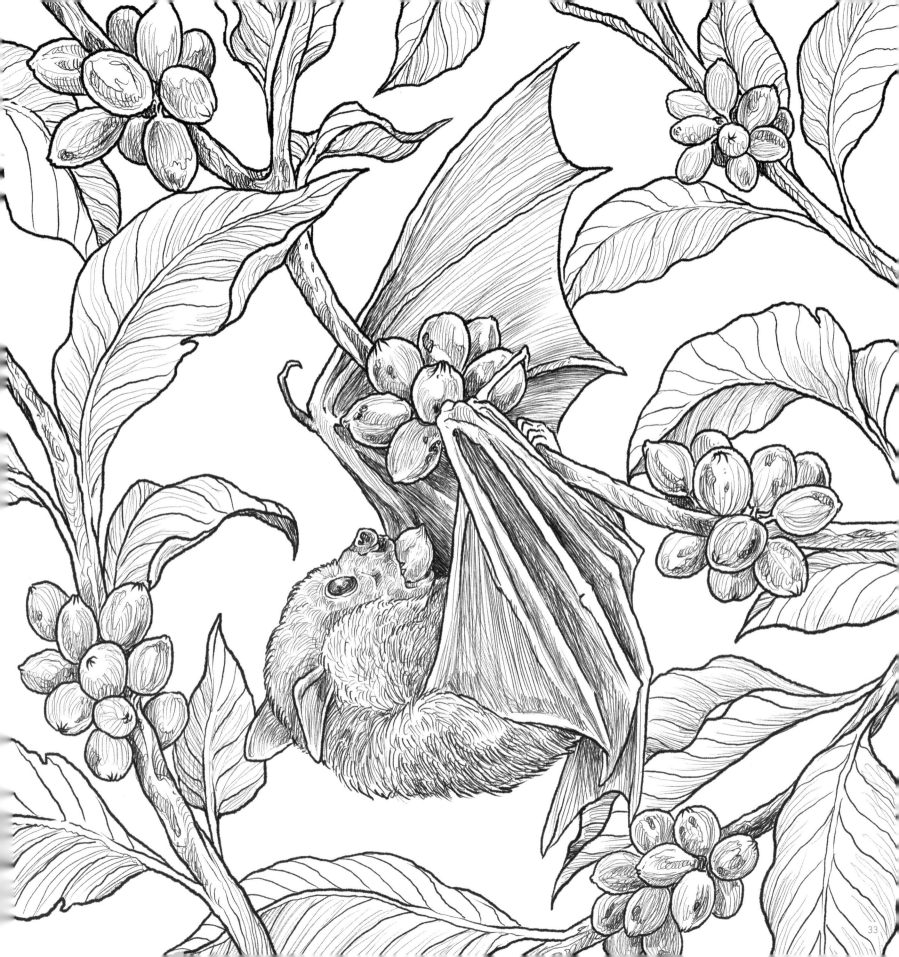

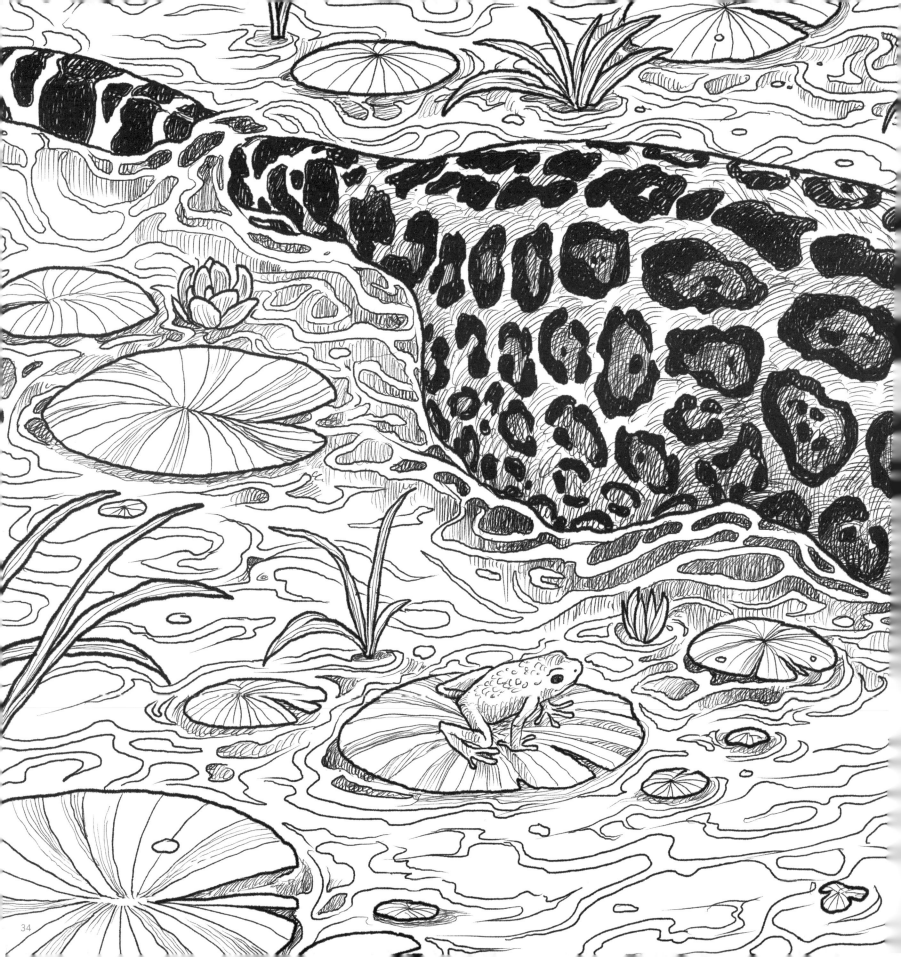

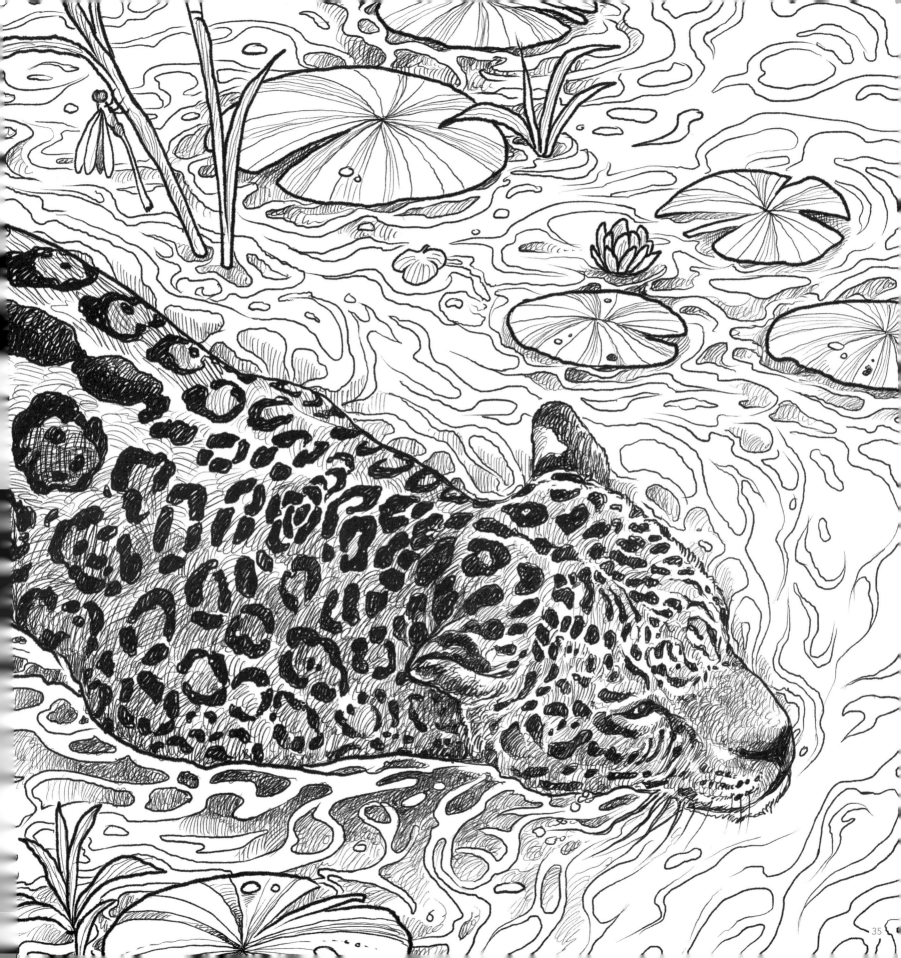

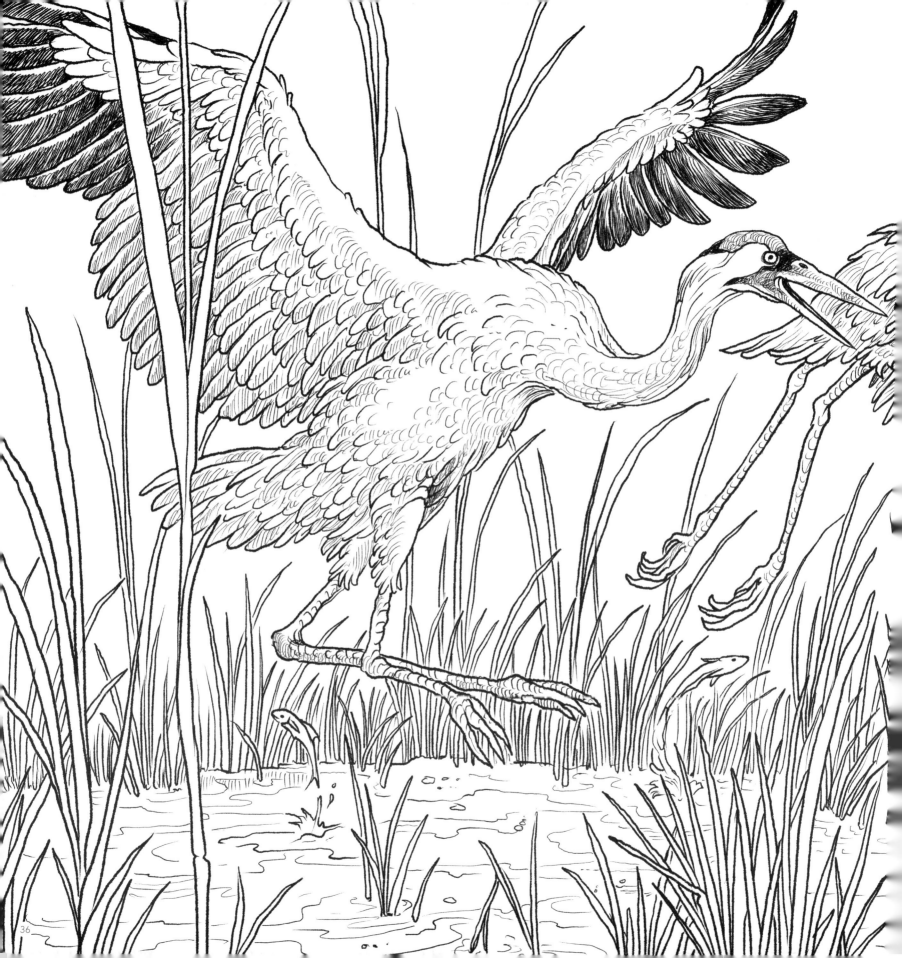

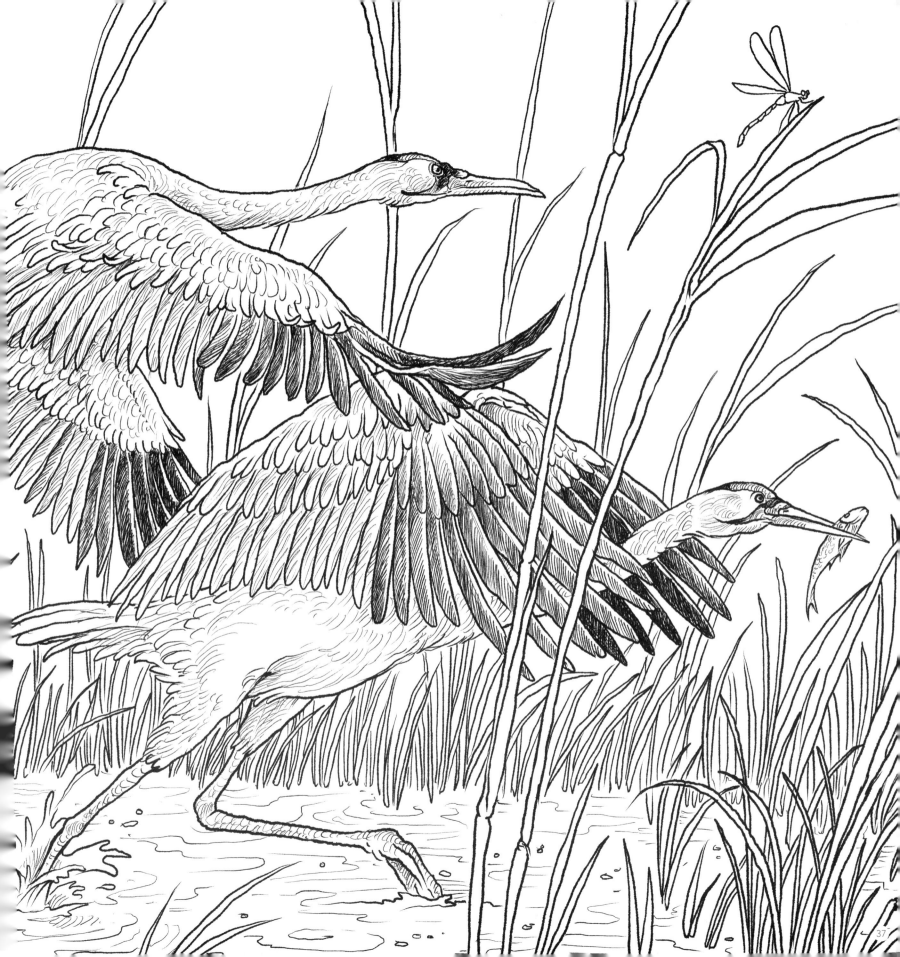

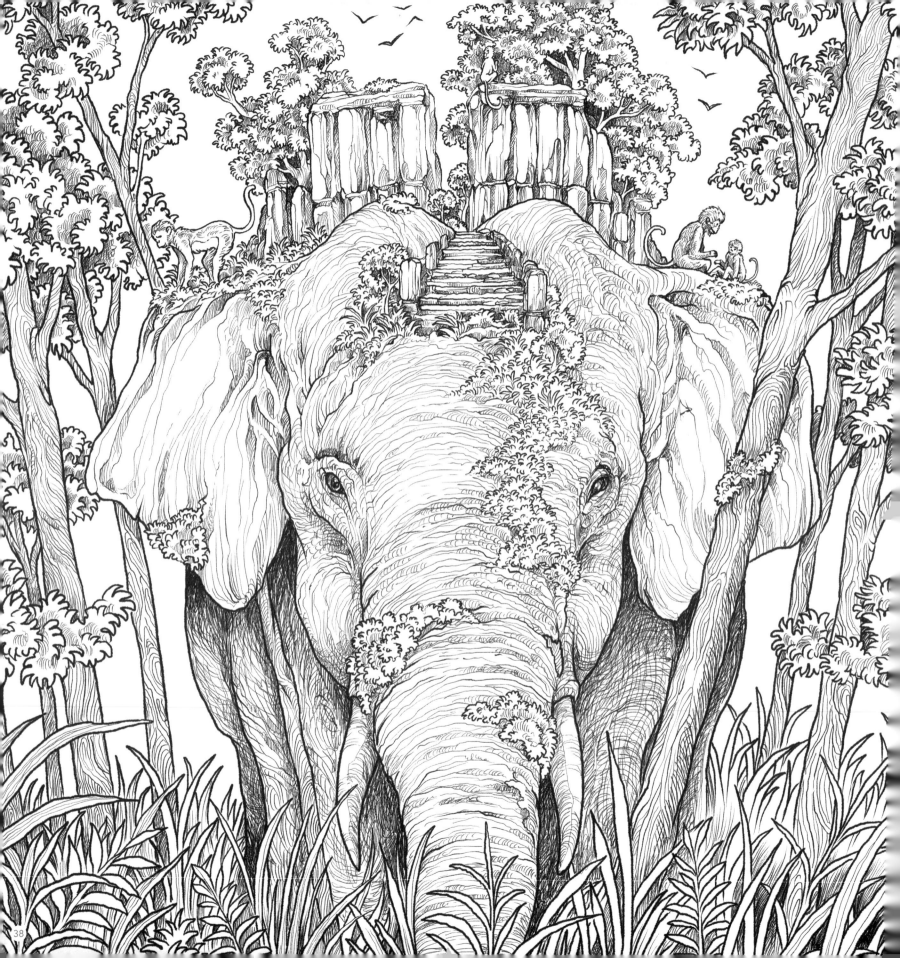

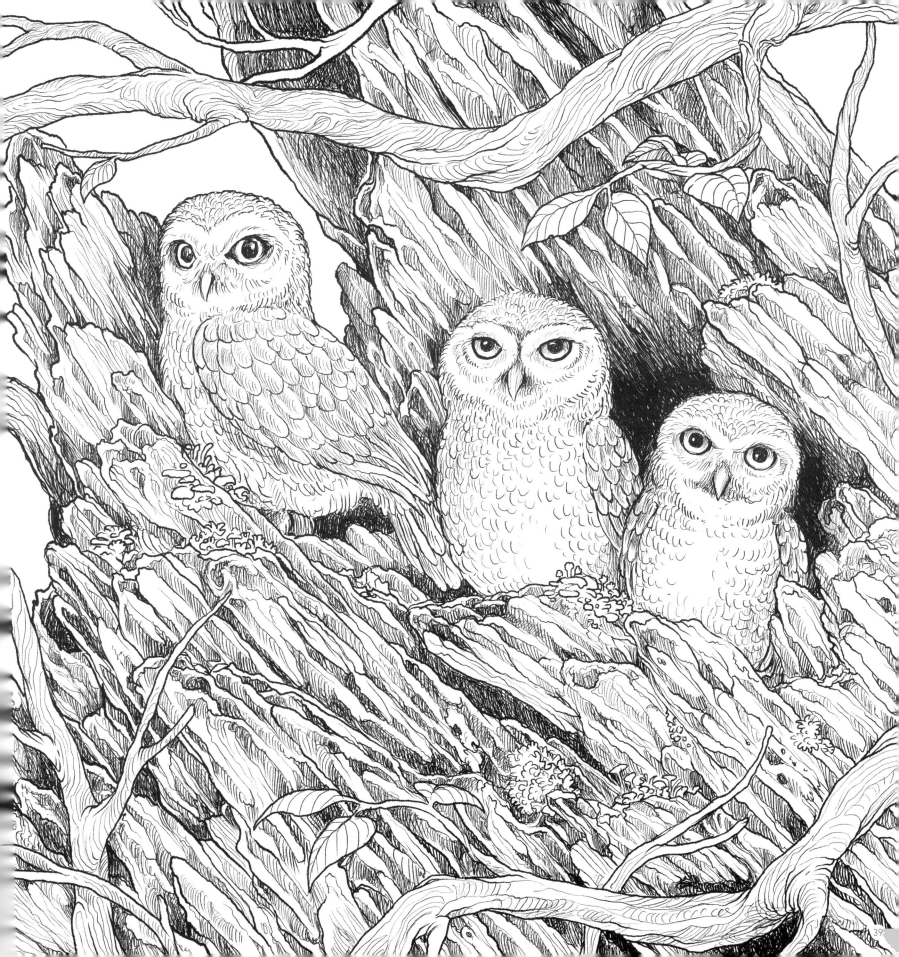

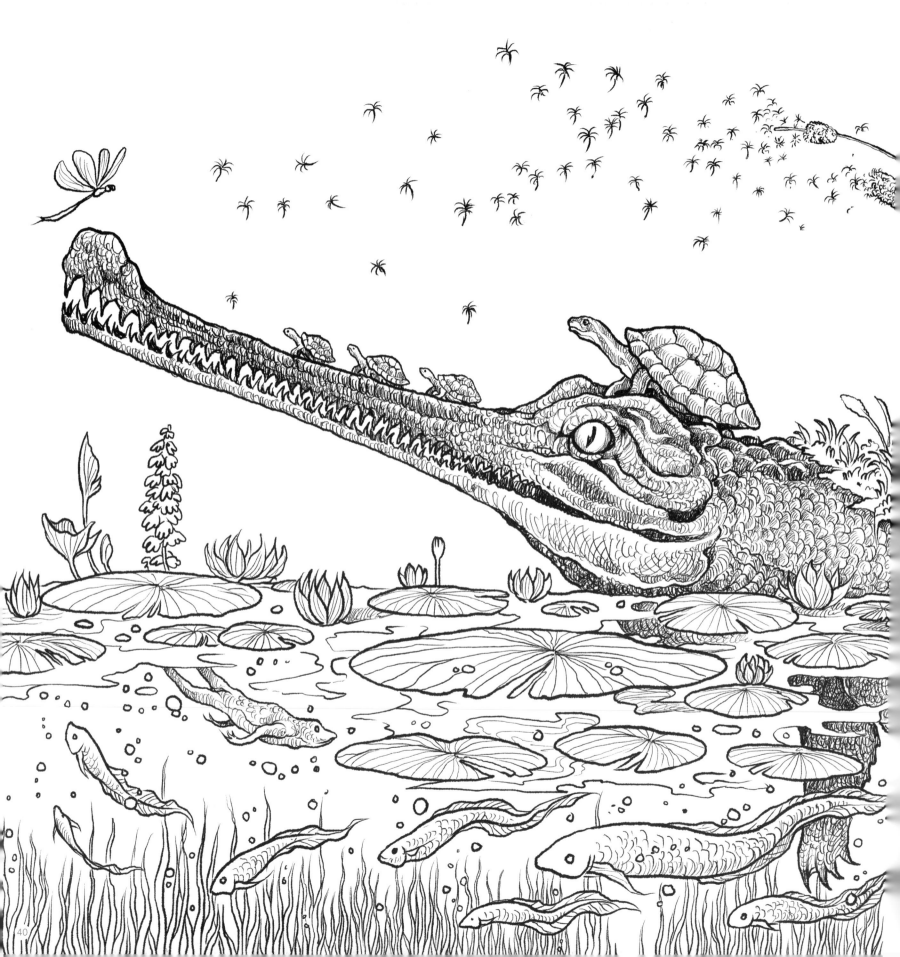

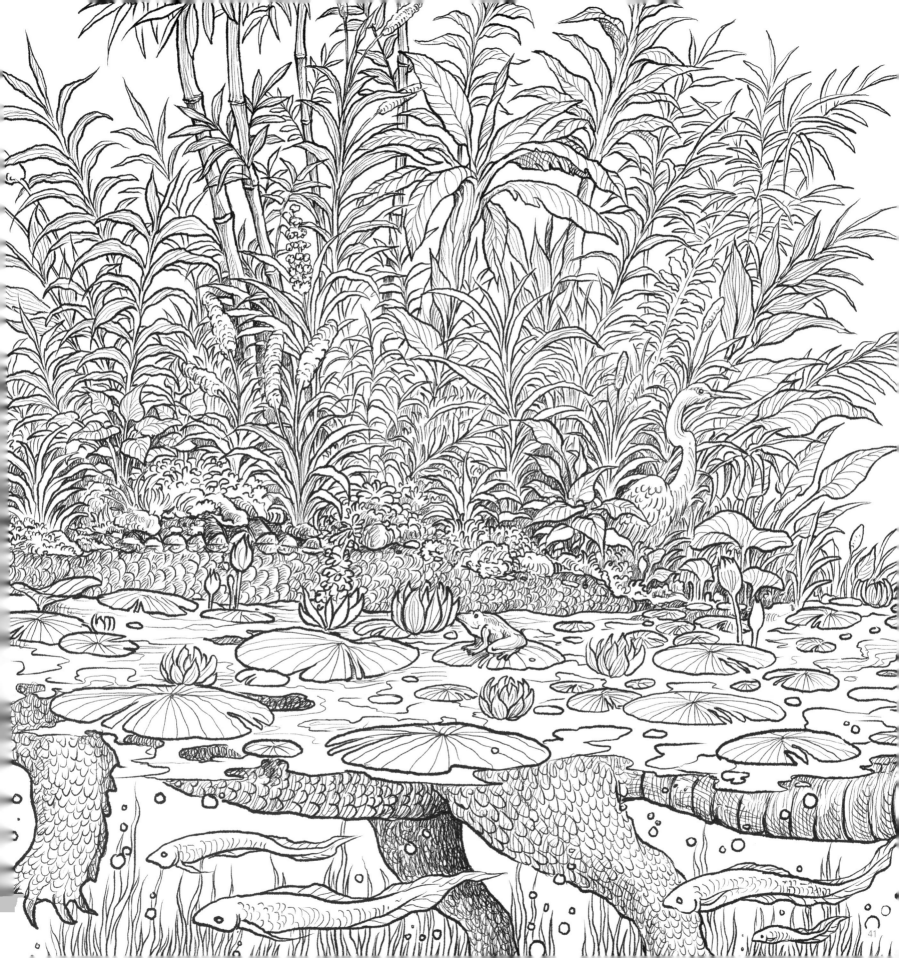

41

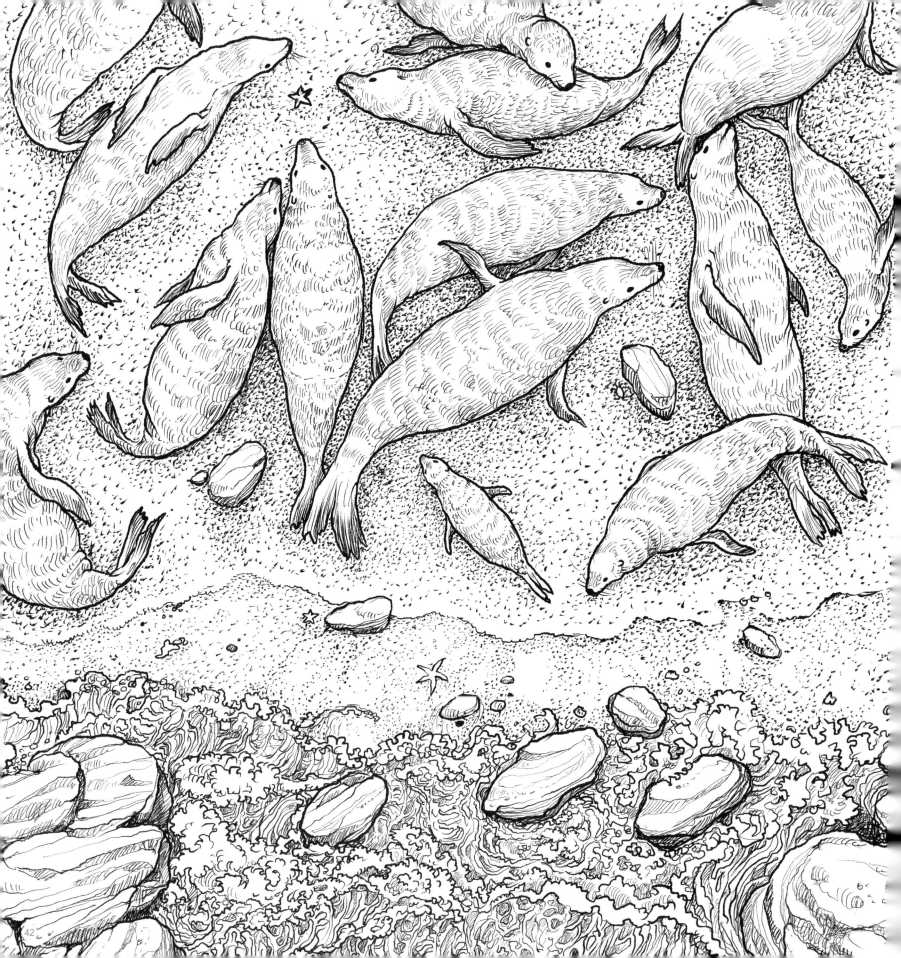

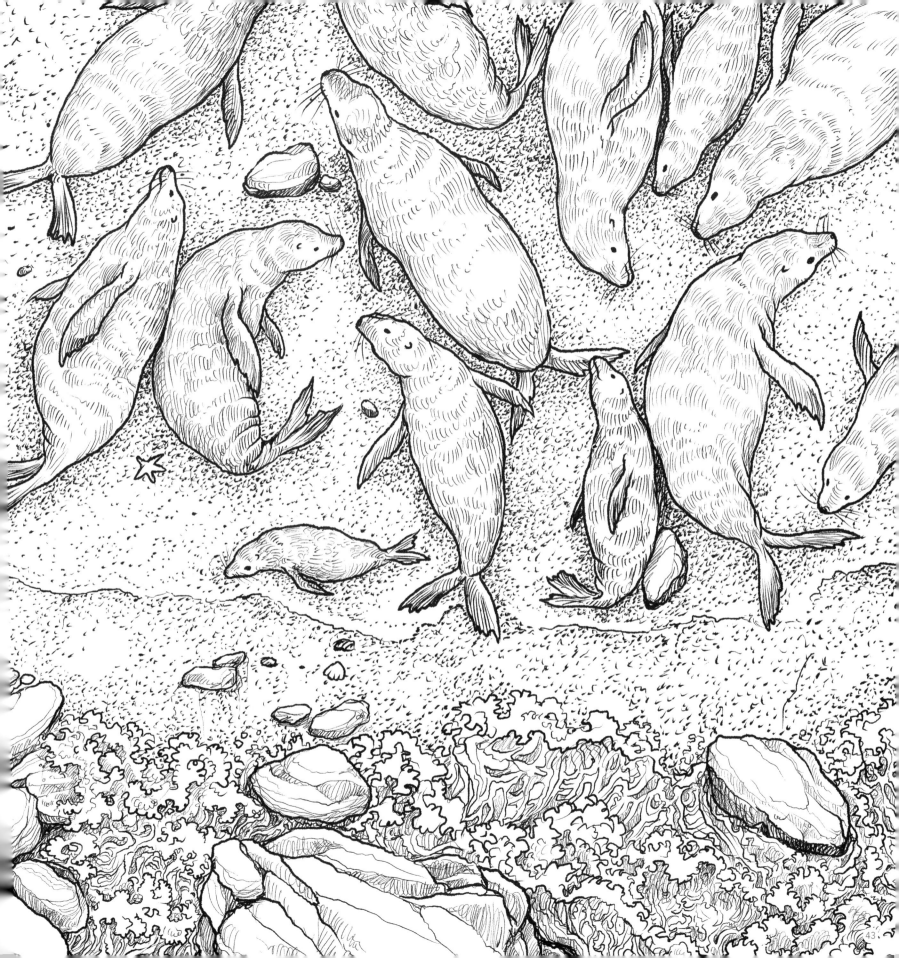

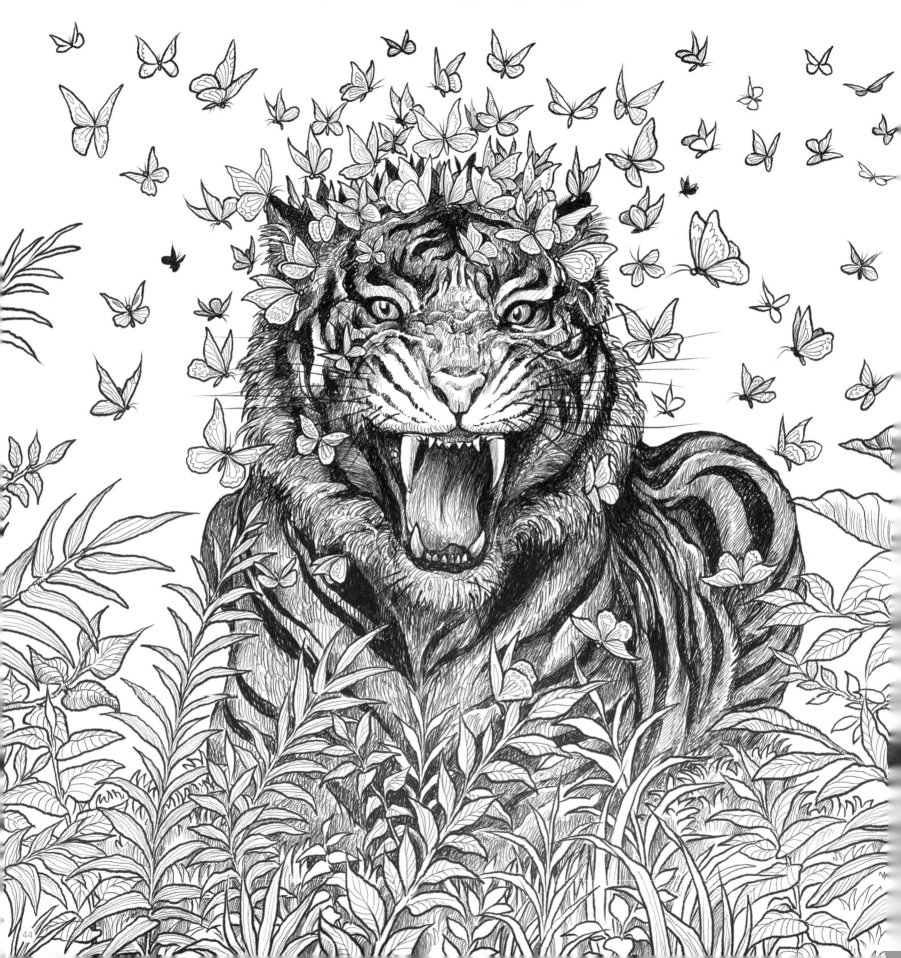

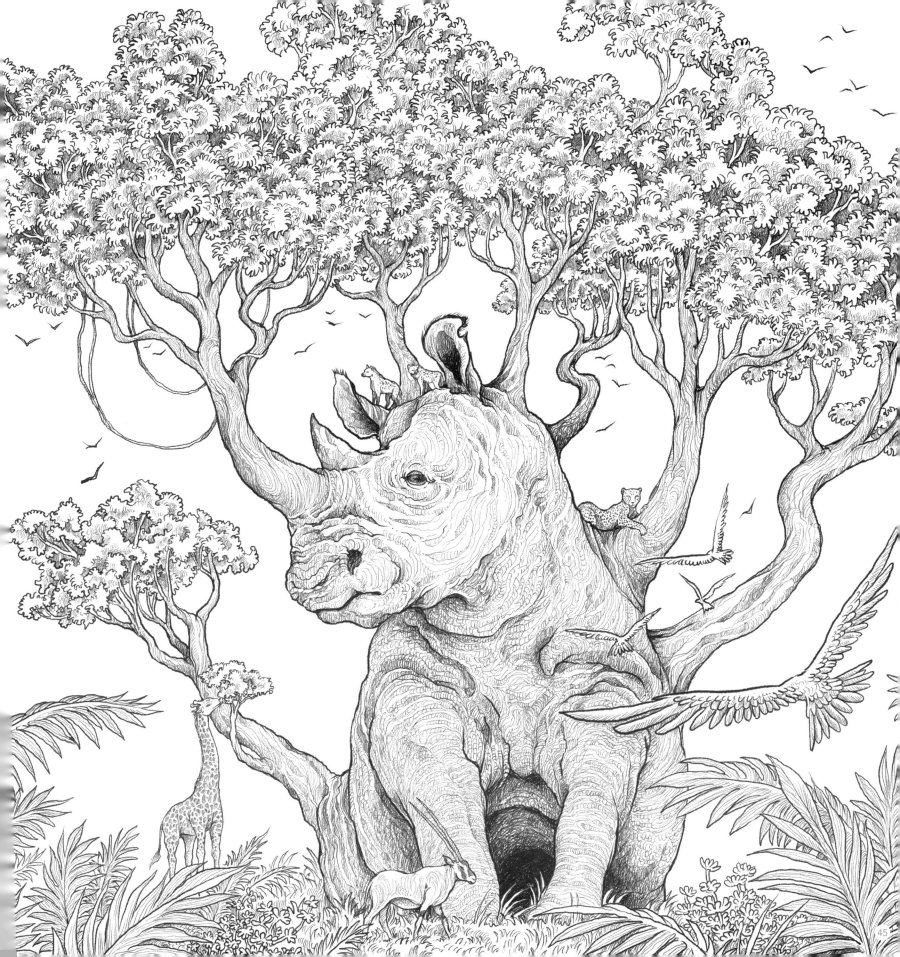

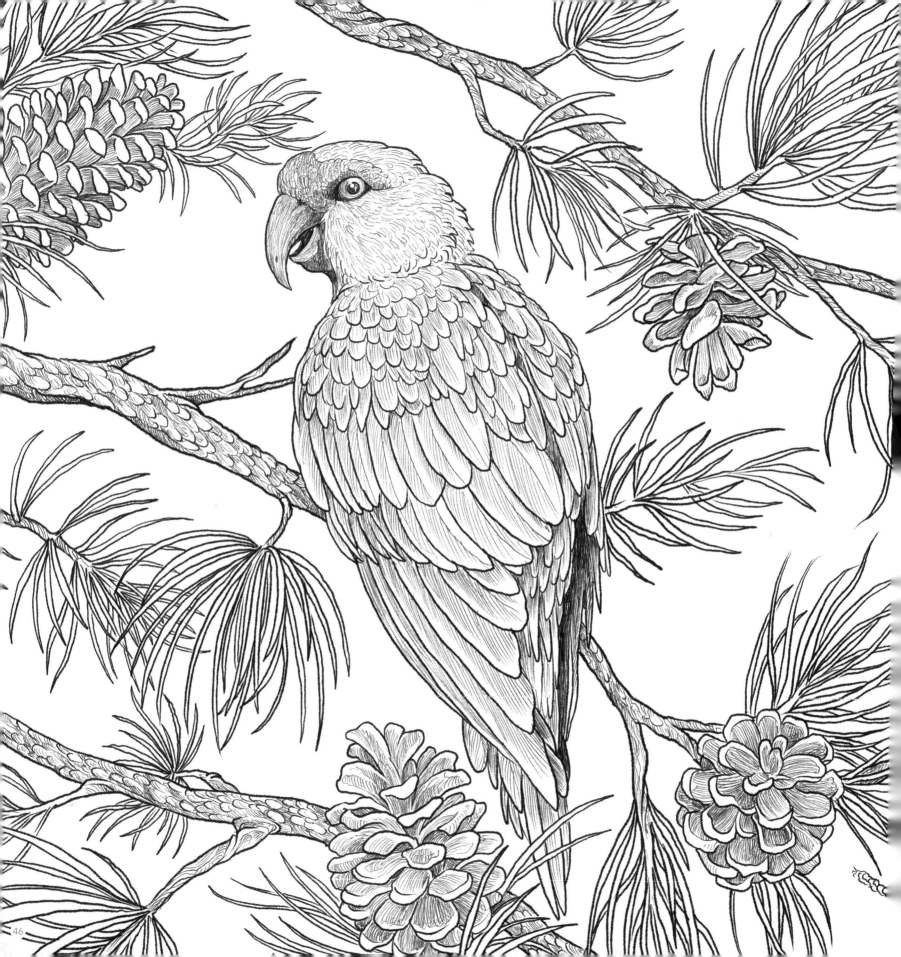

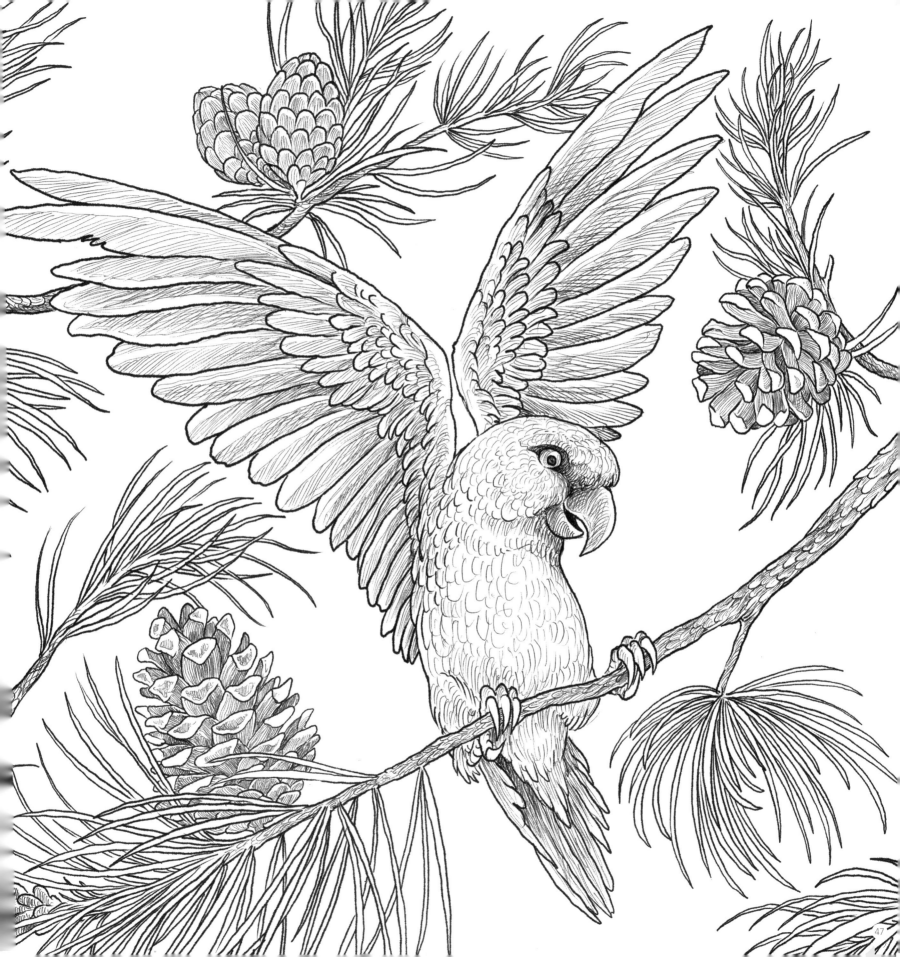

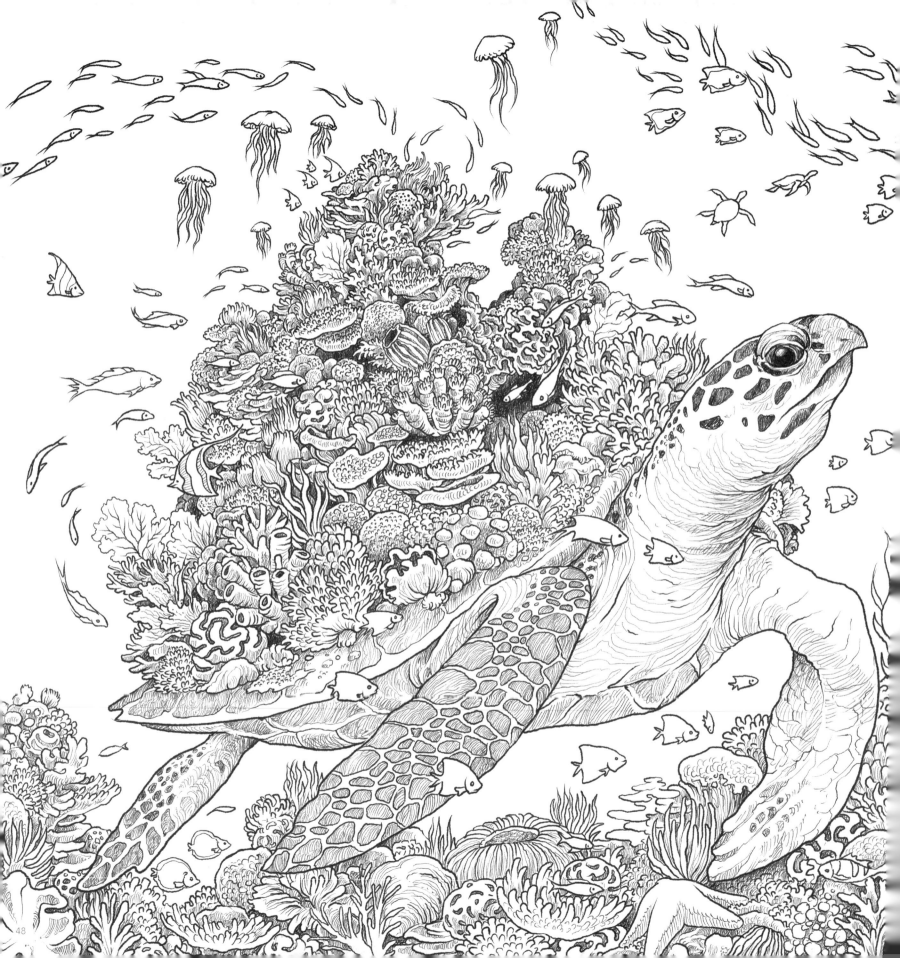

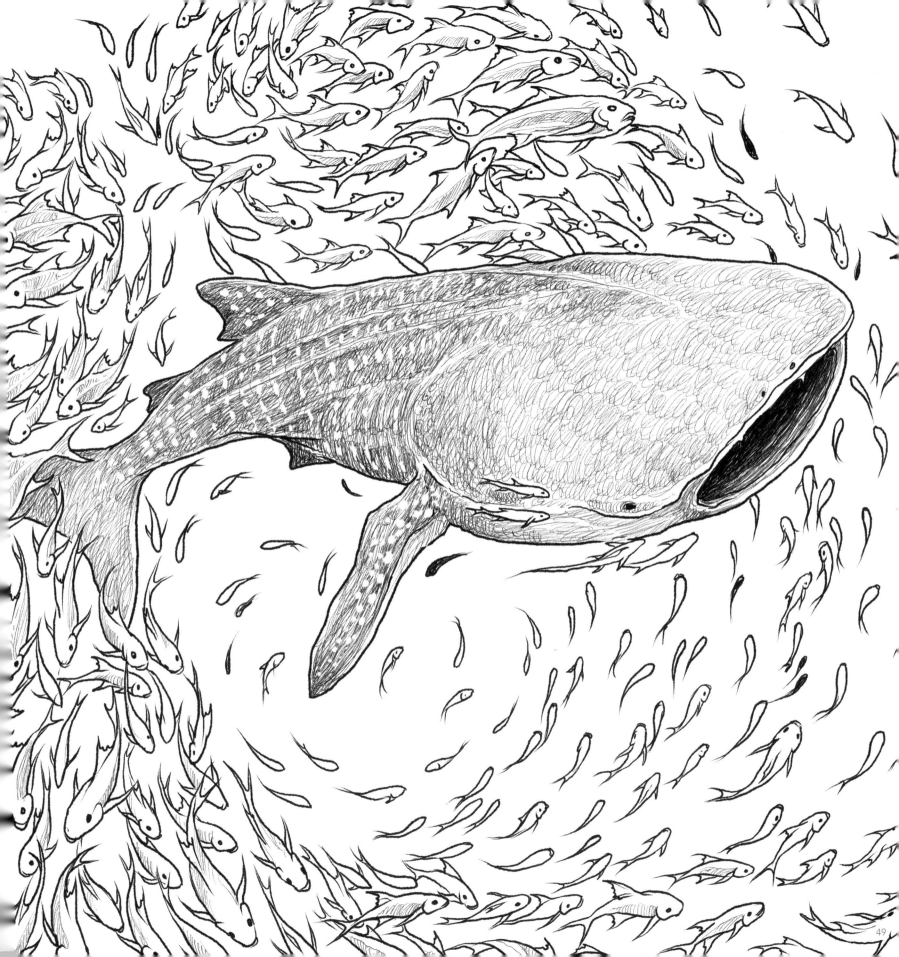

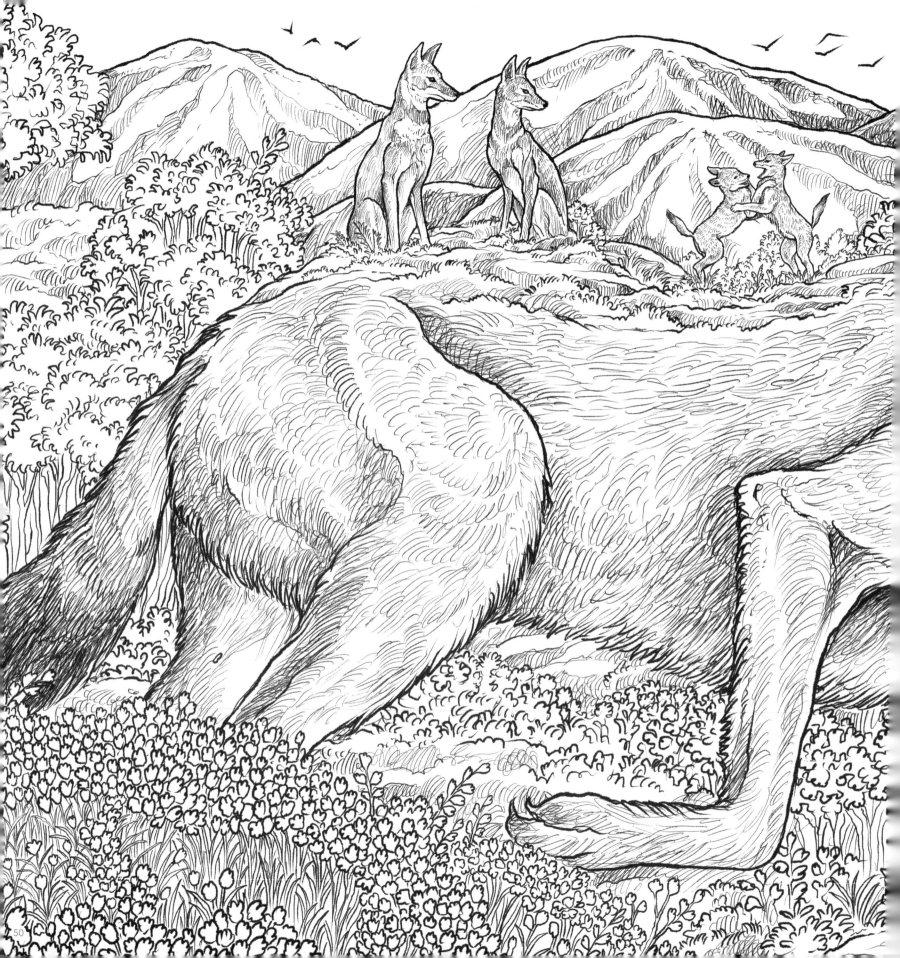

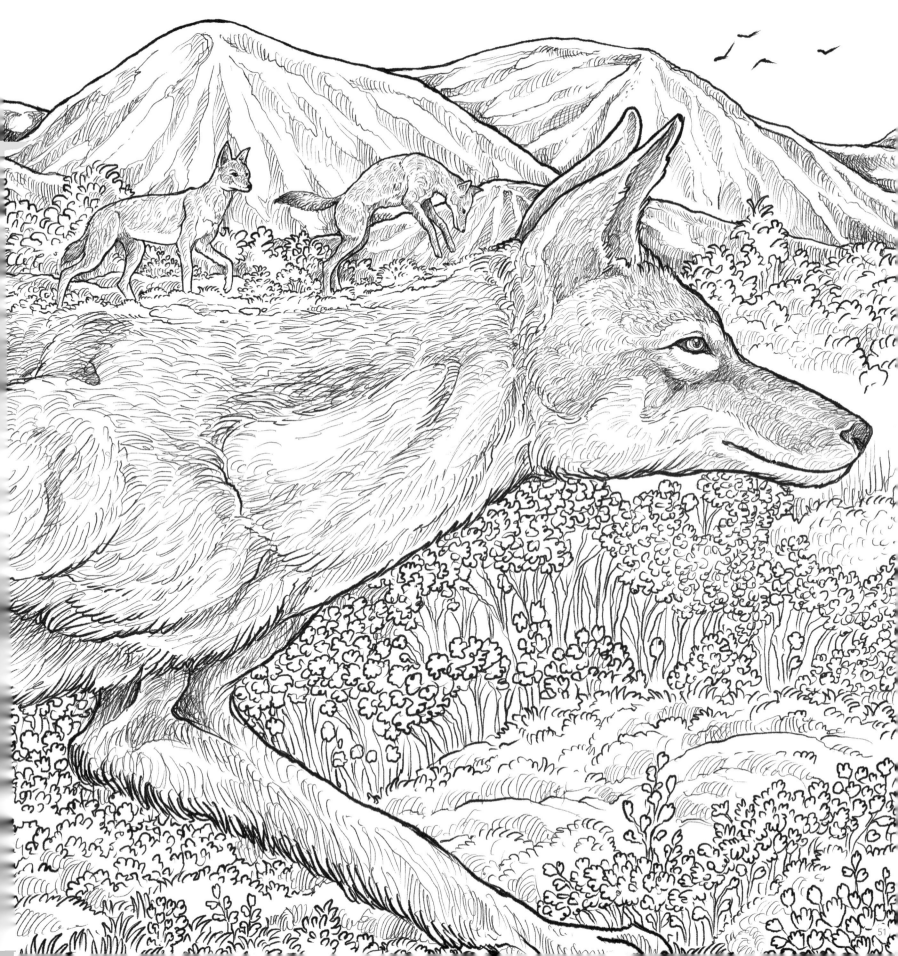

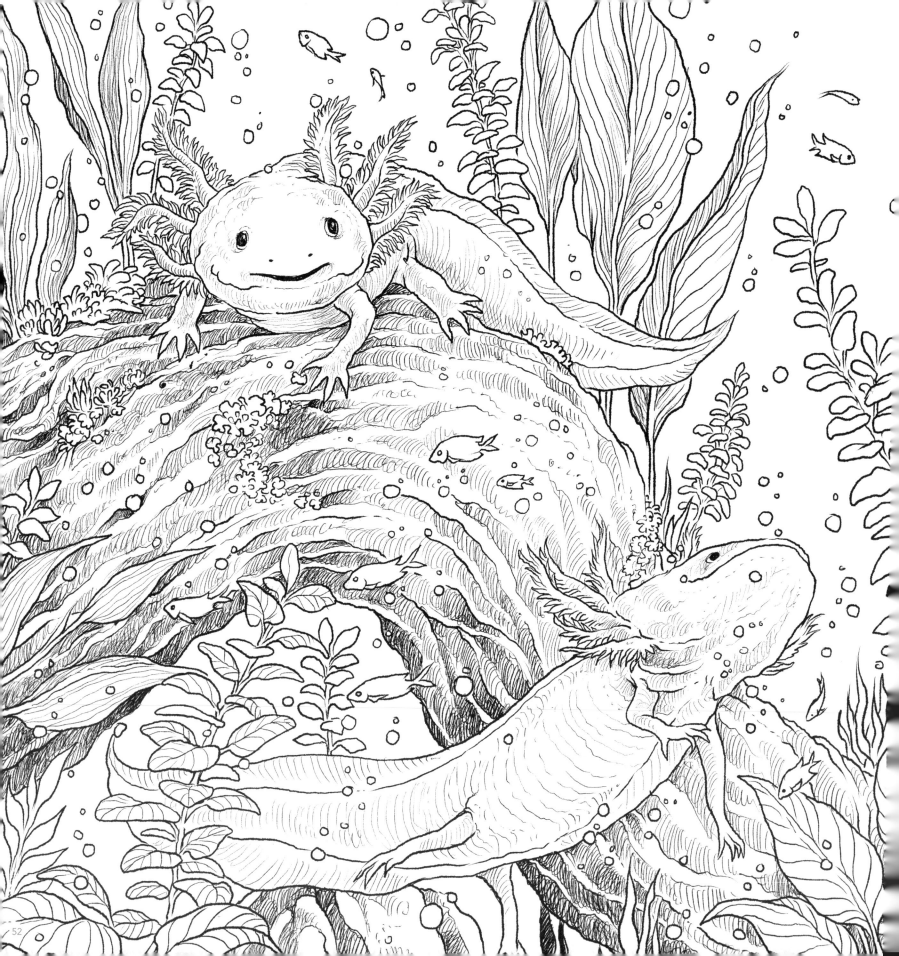

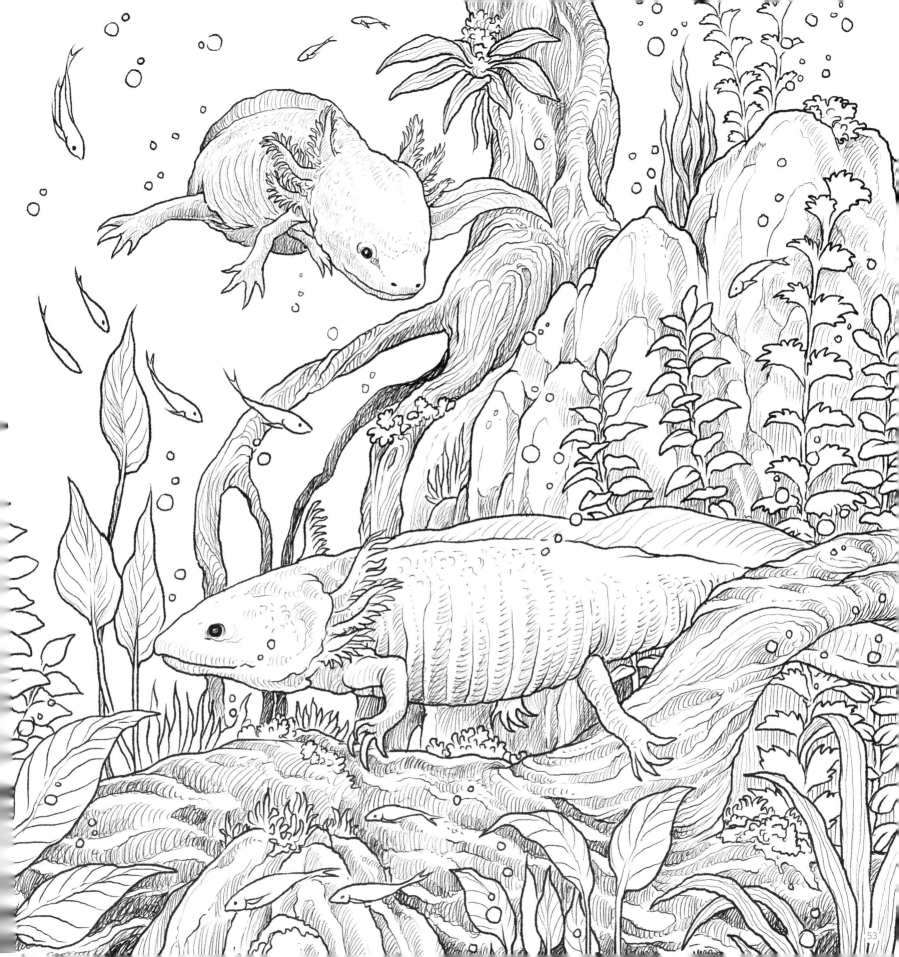

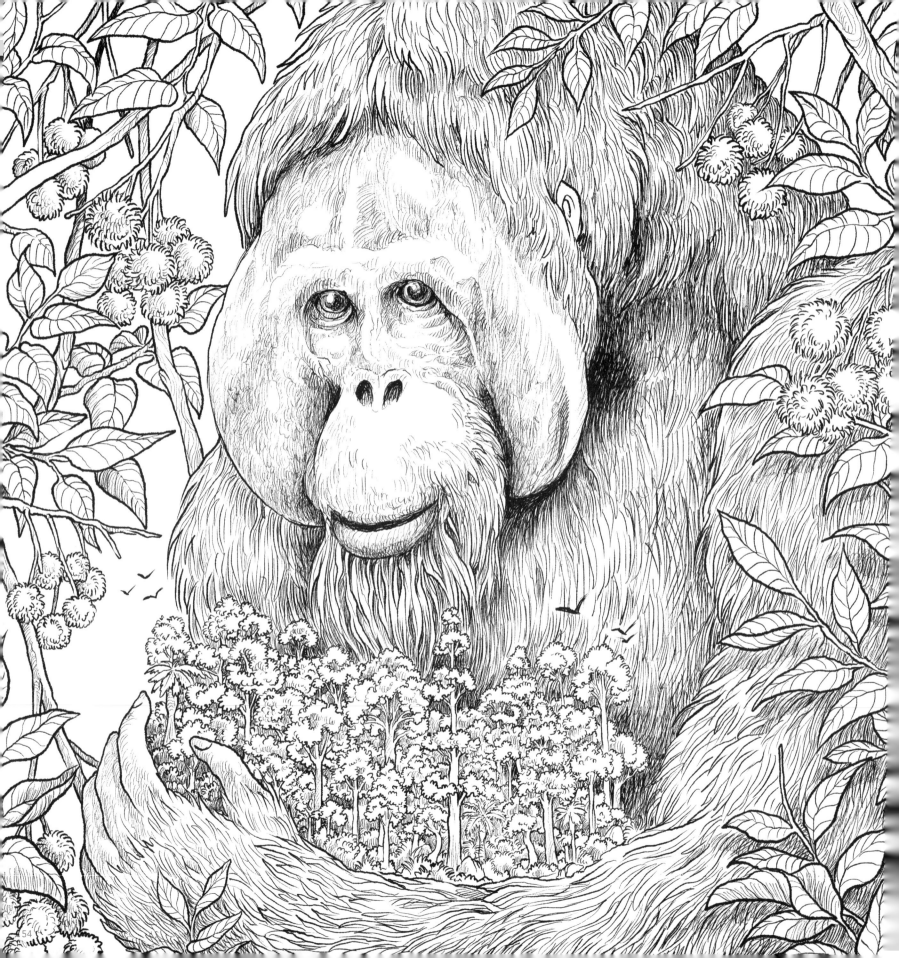

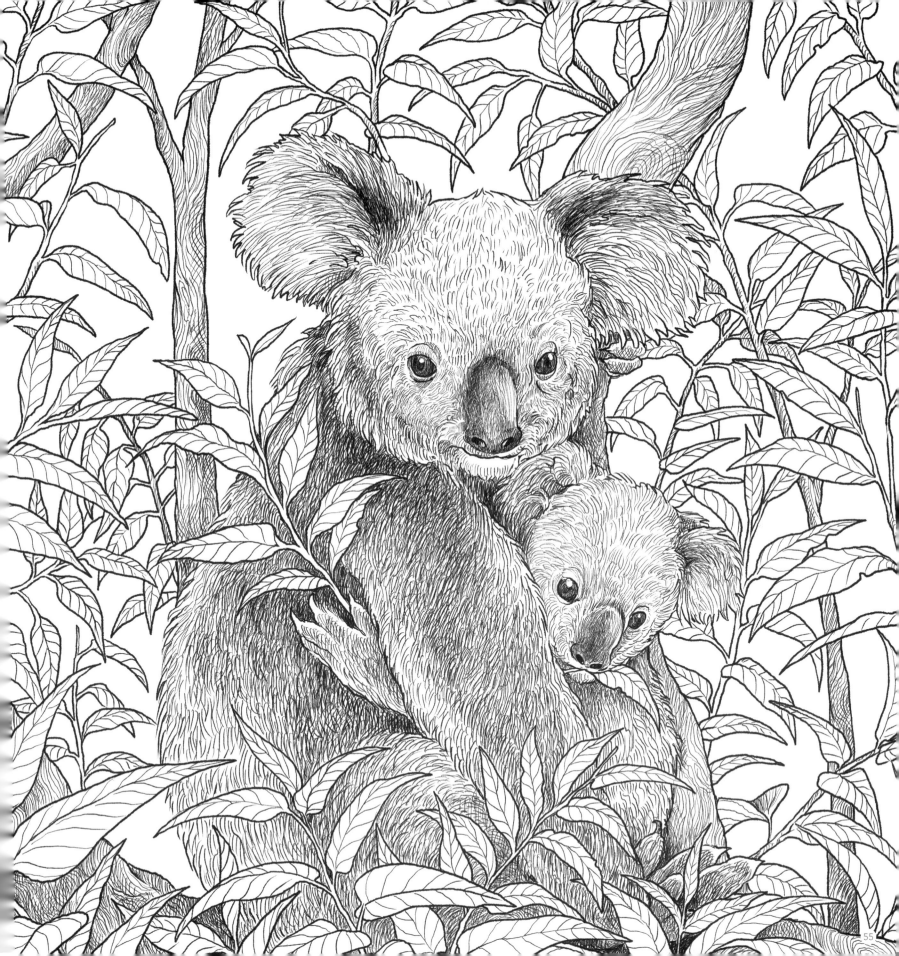

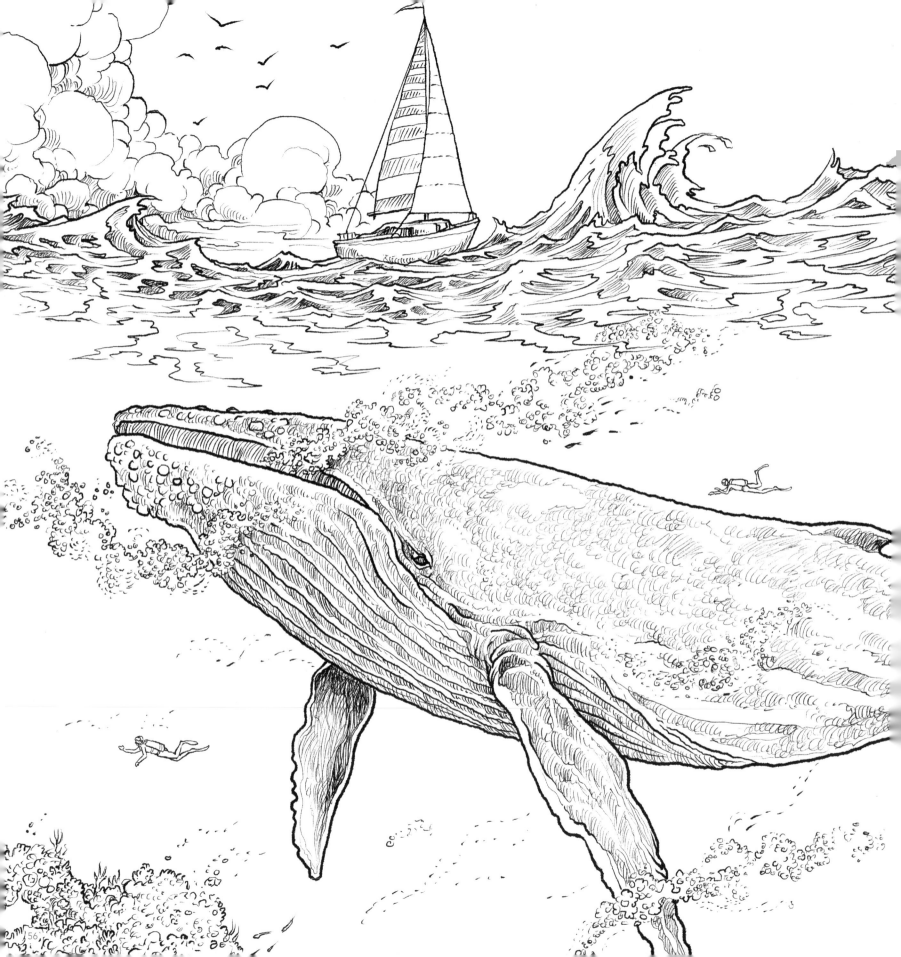

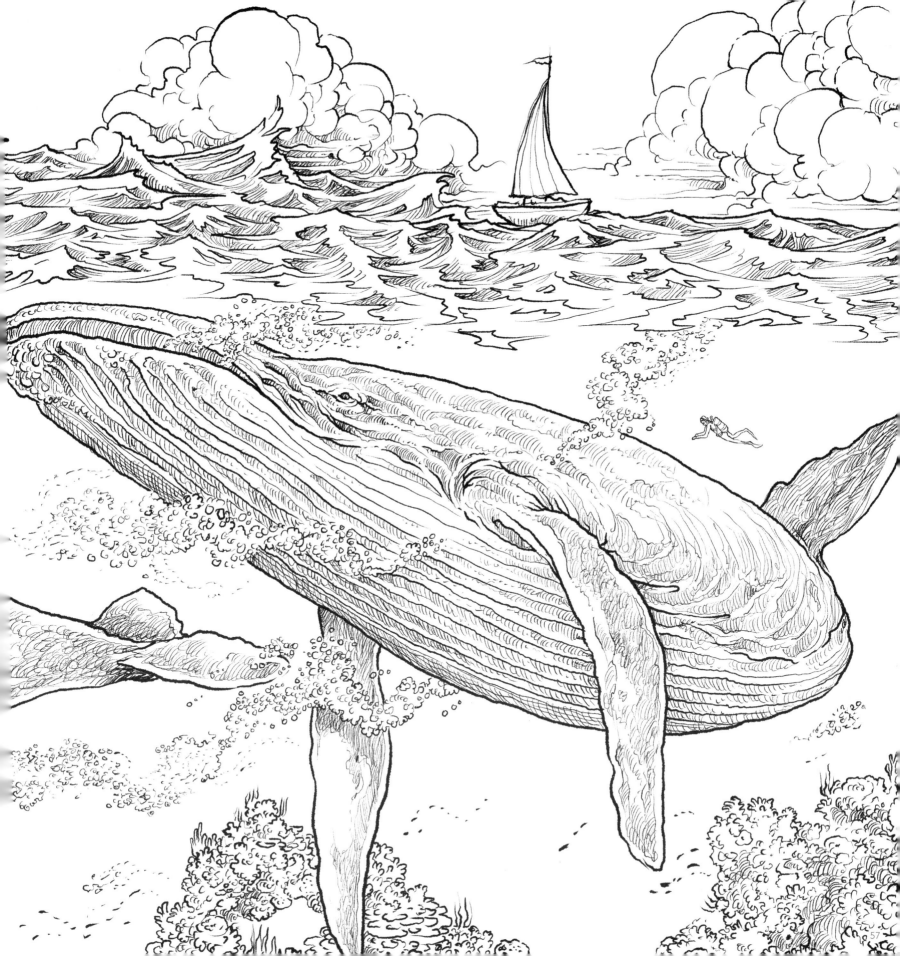

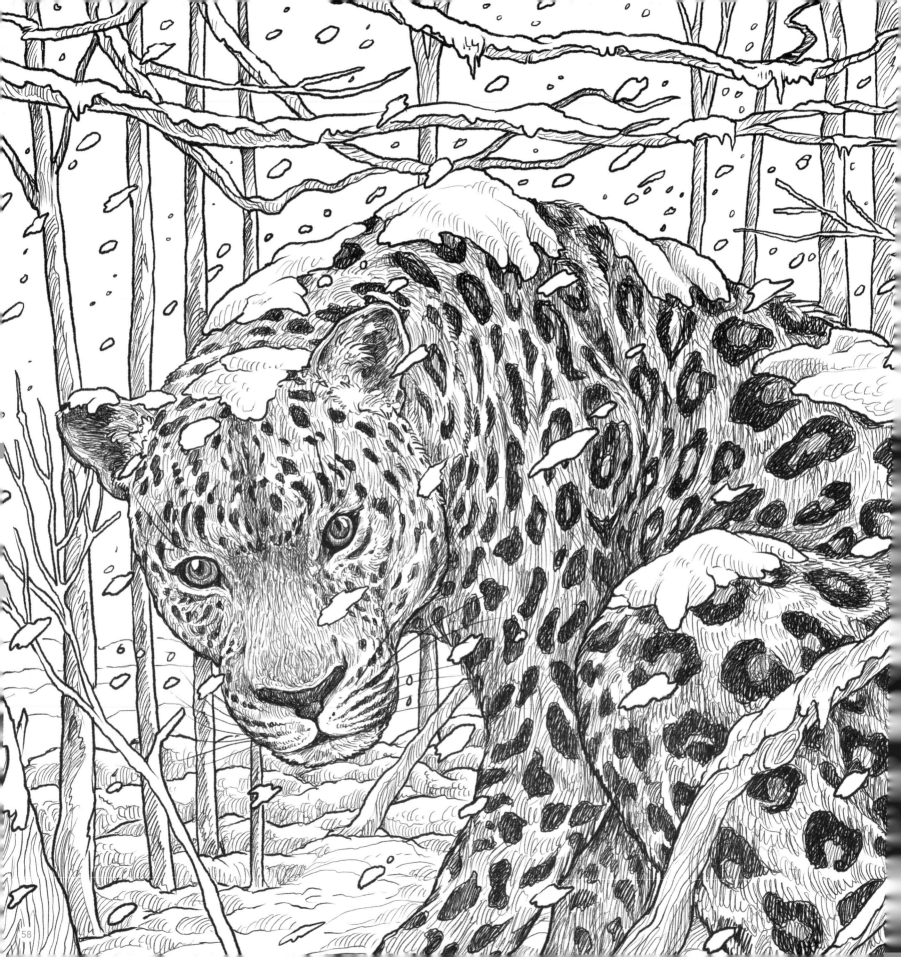

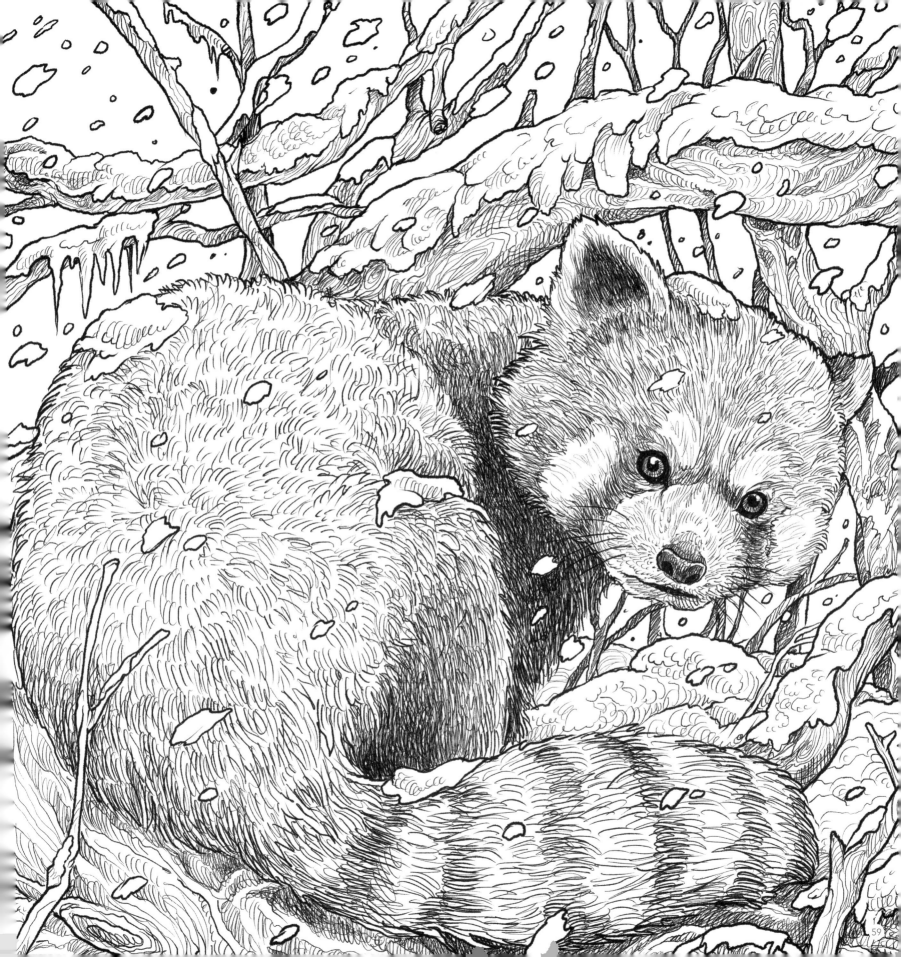

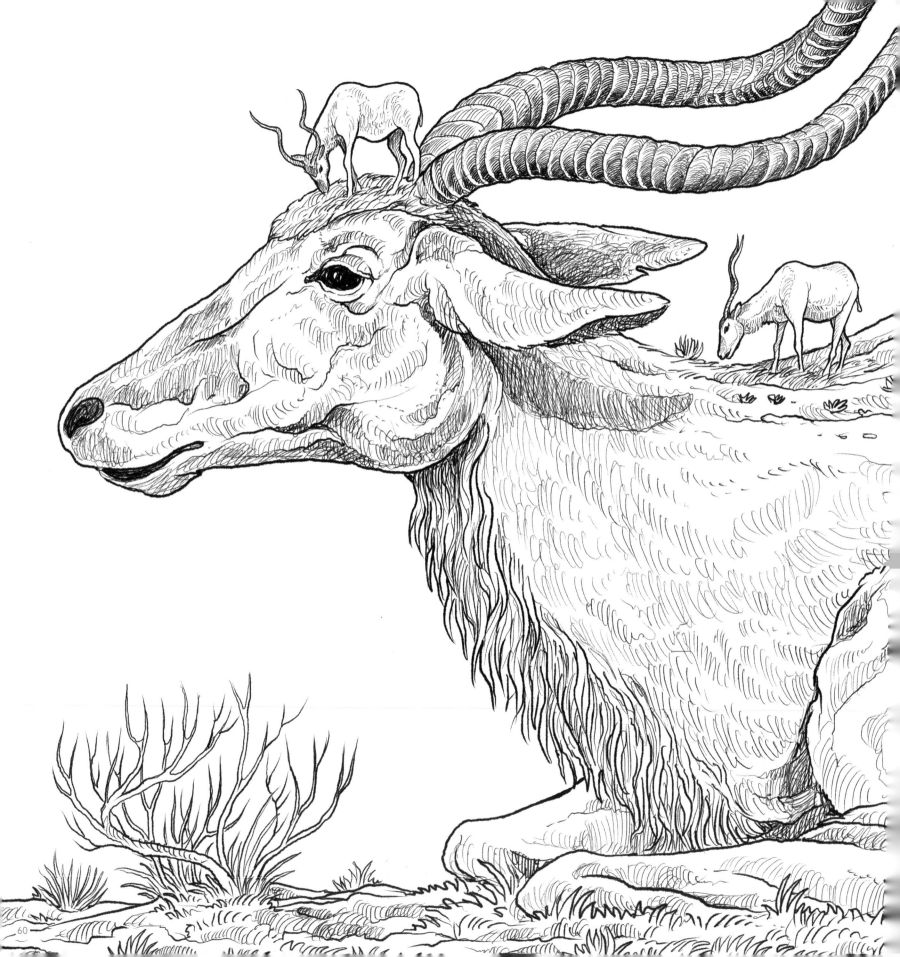

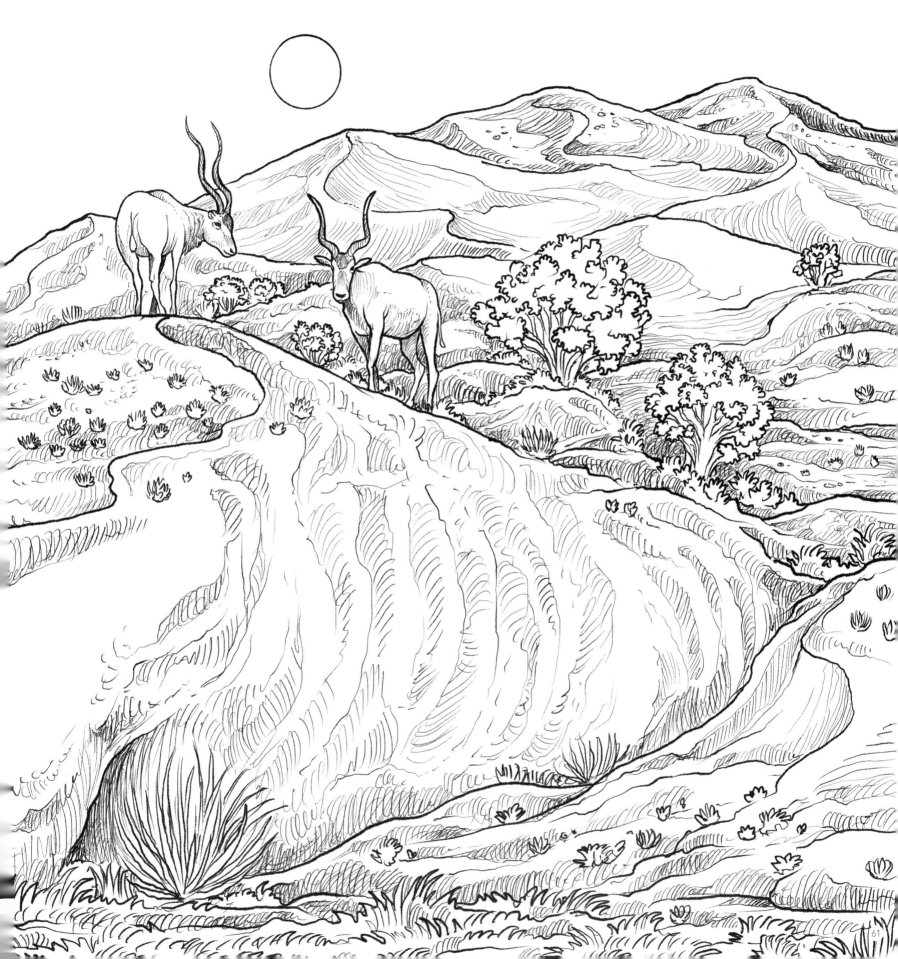

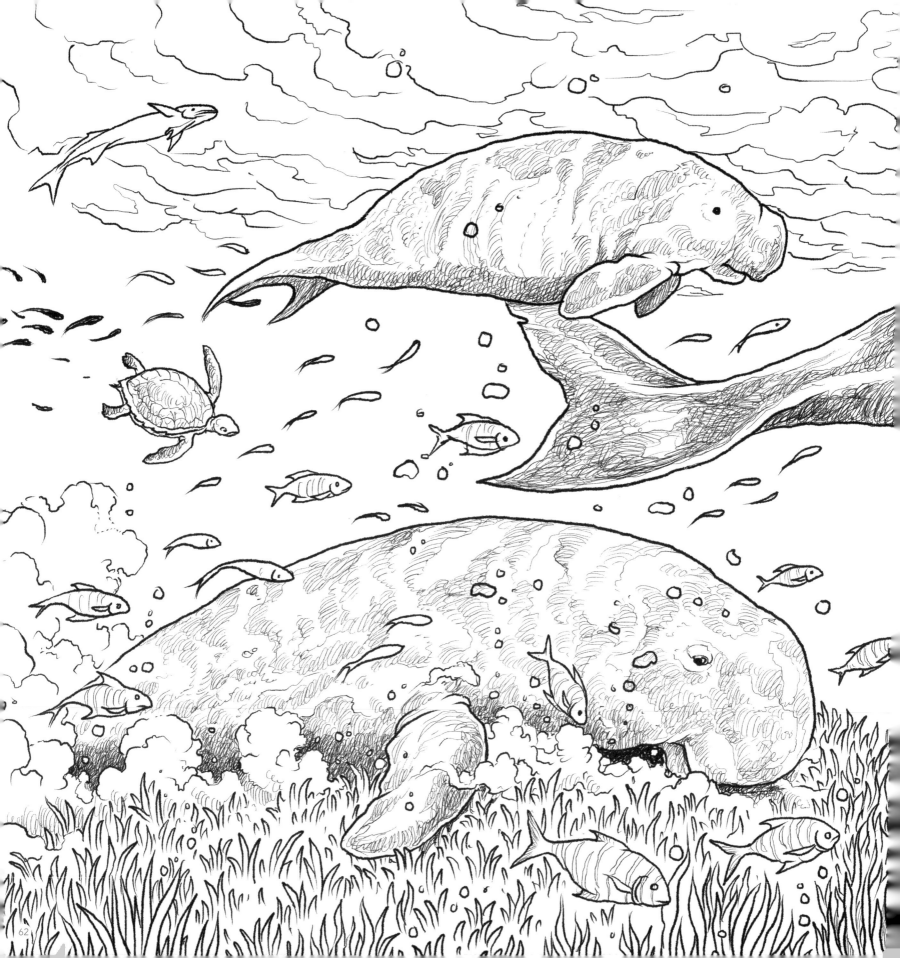

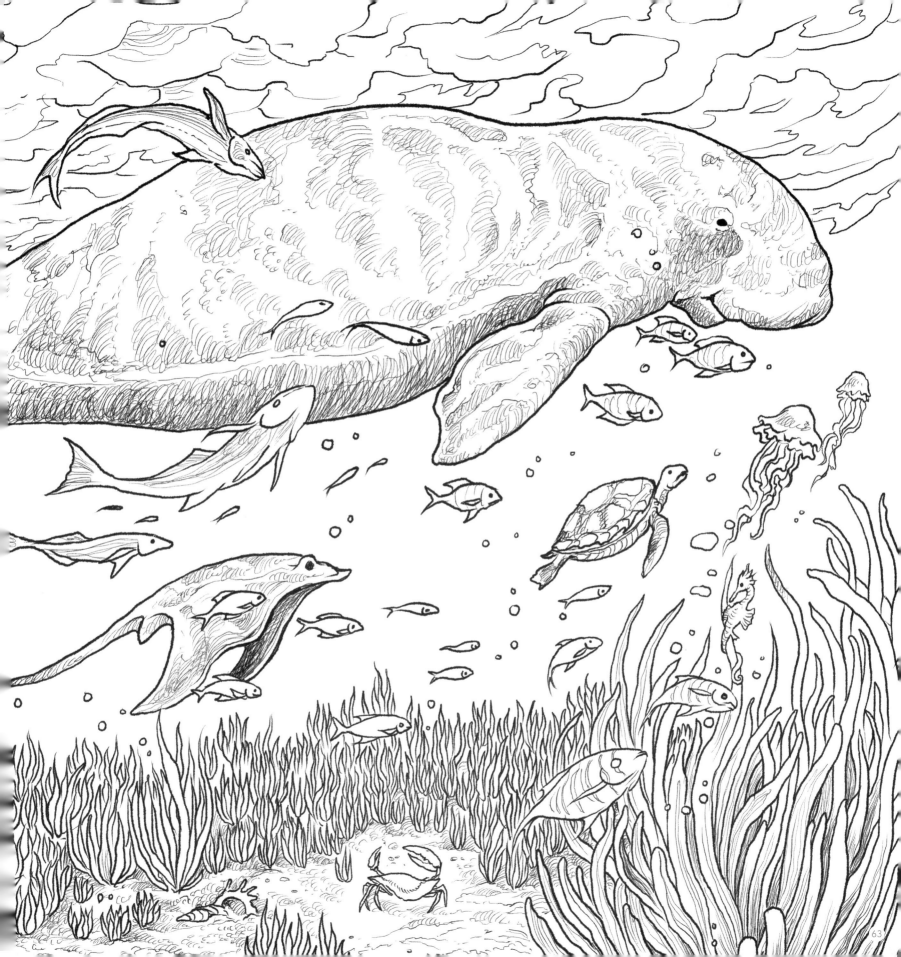

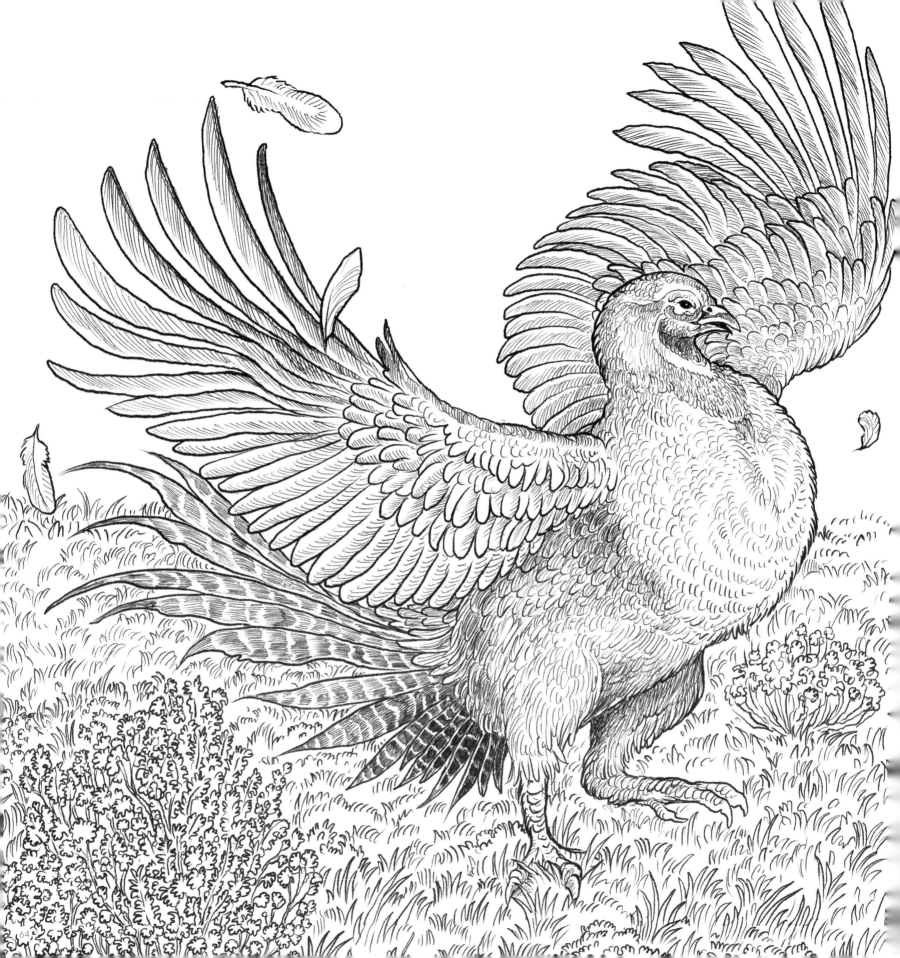

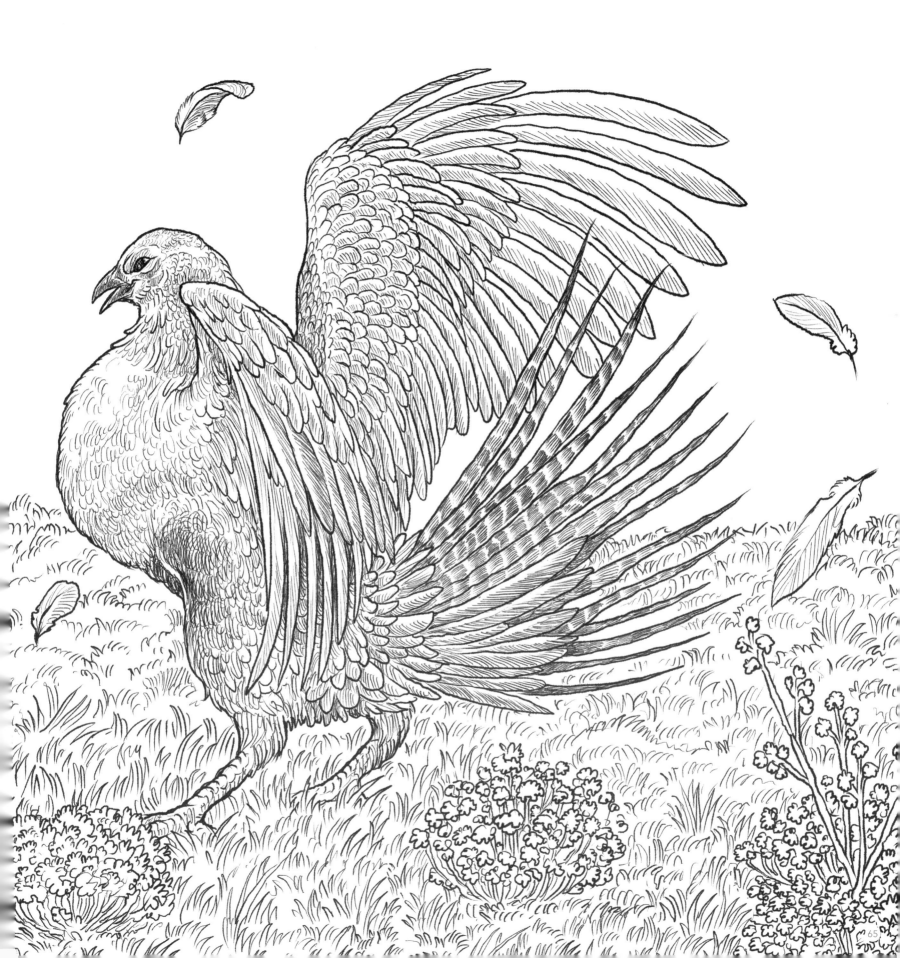

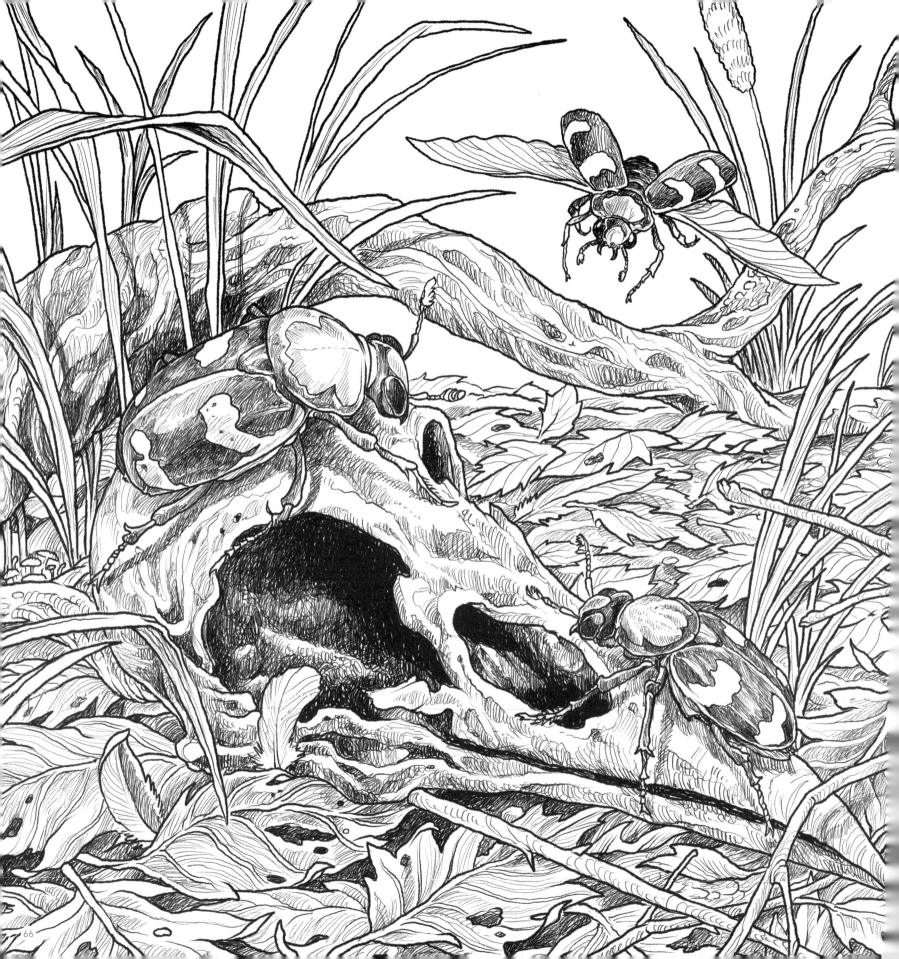

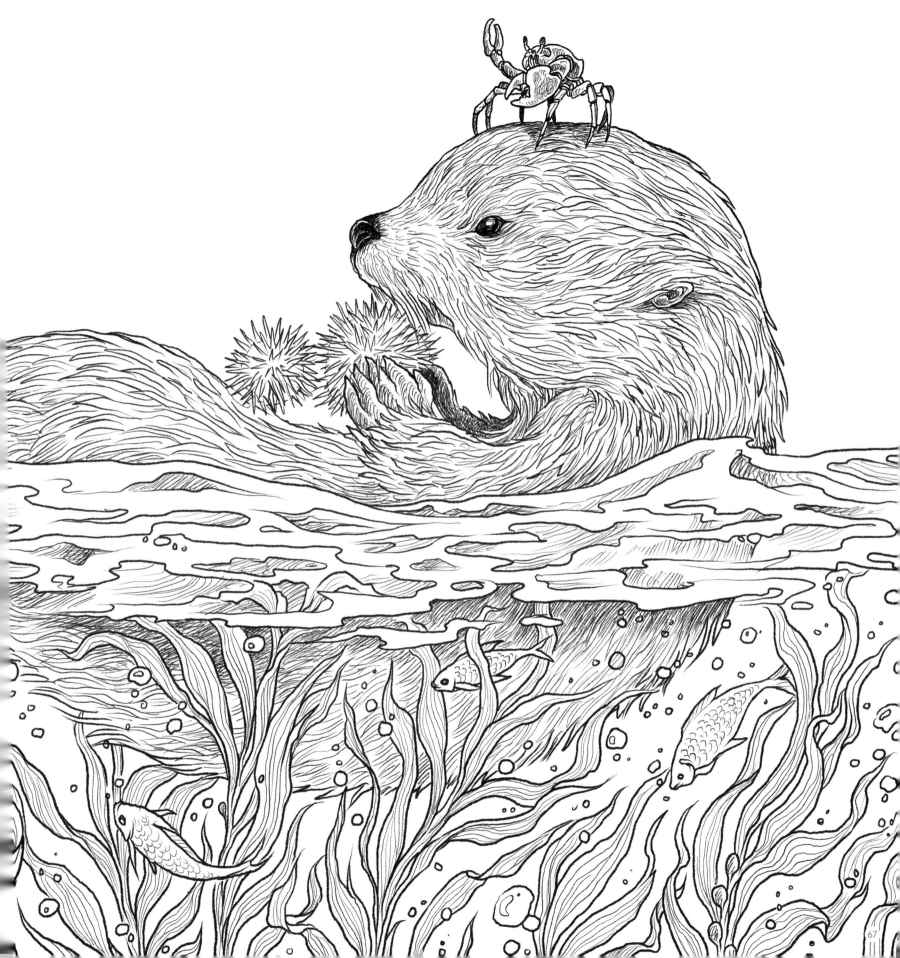

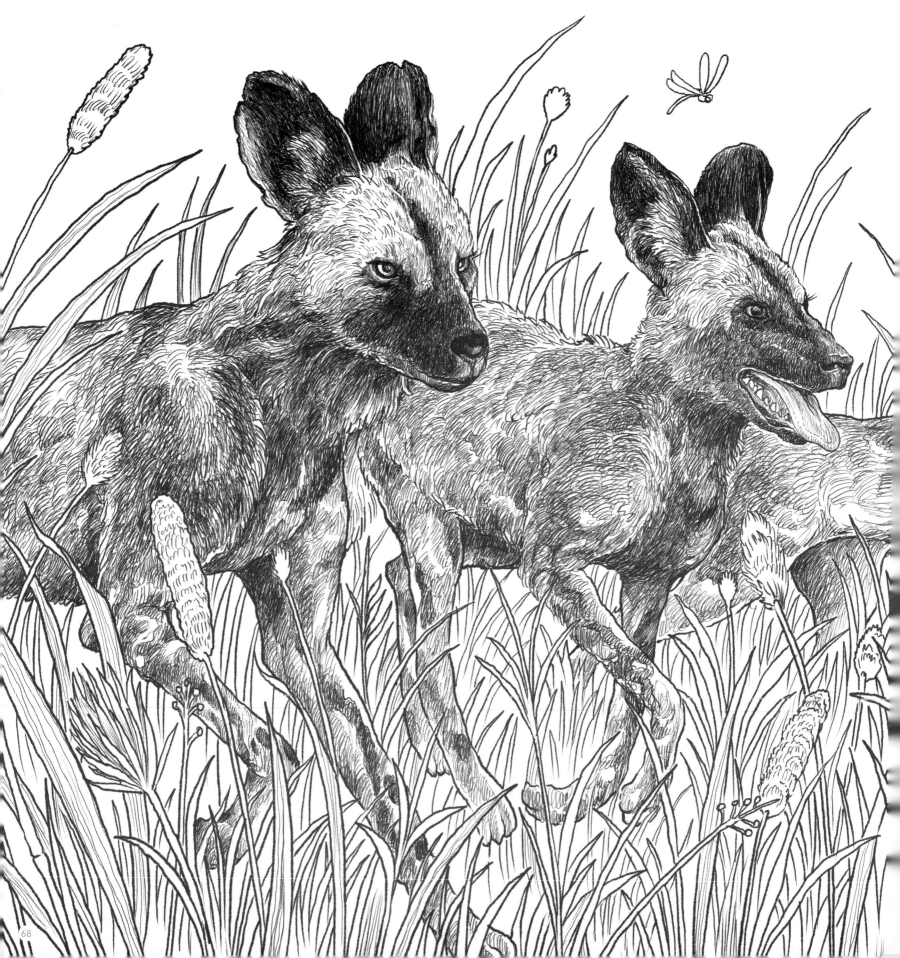

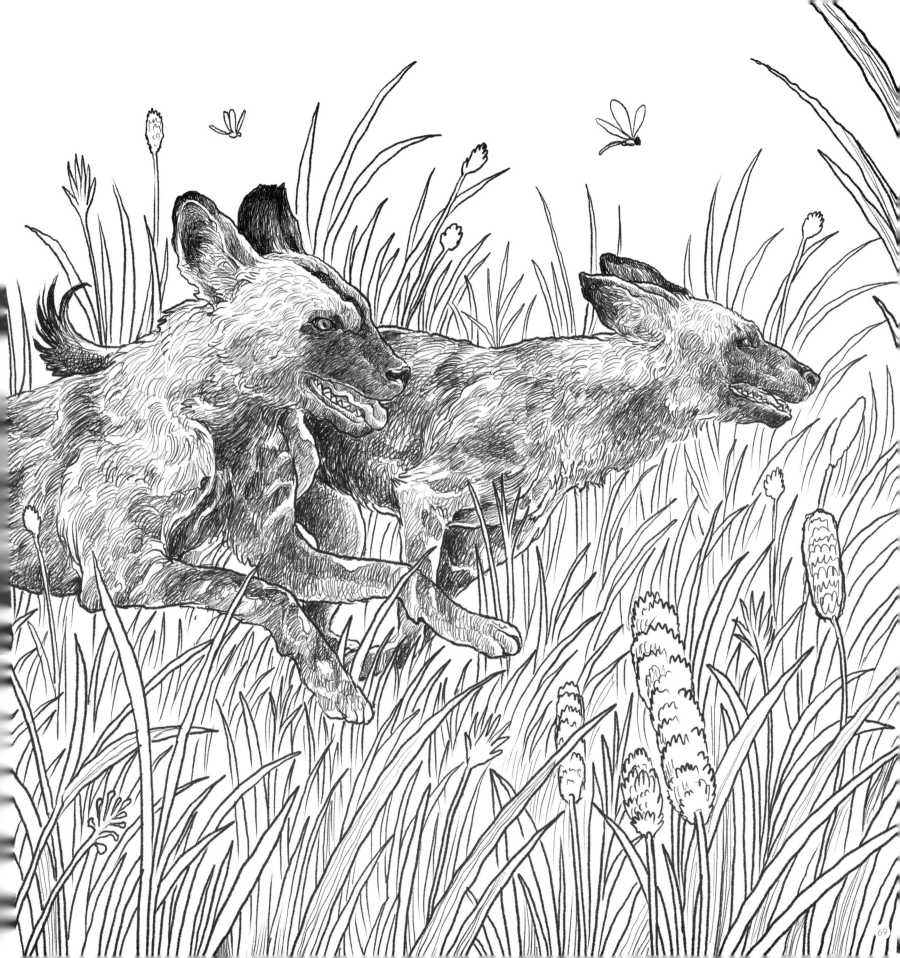

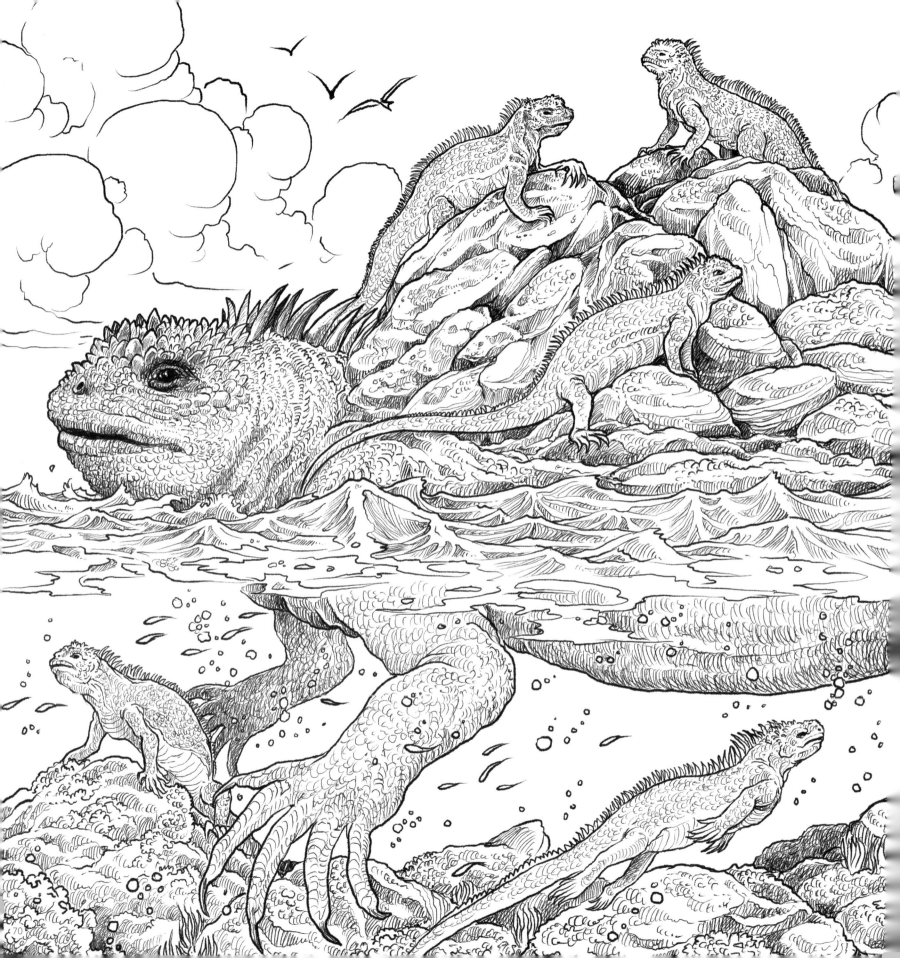

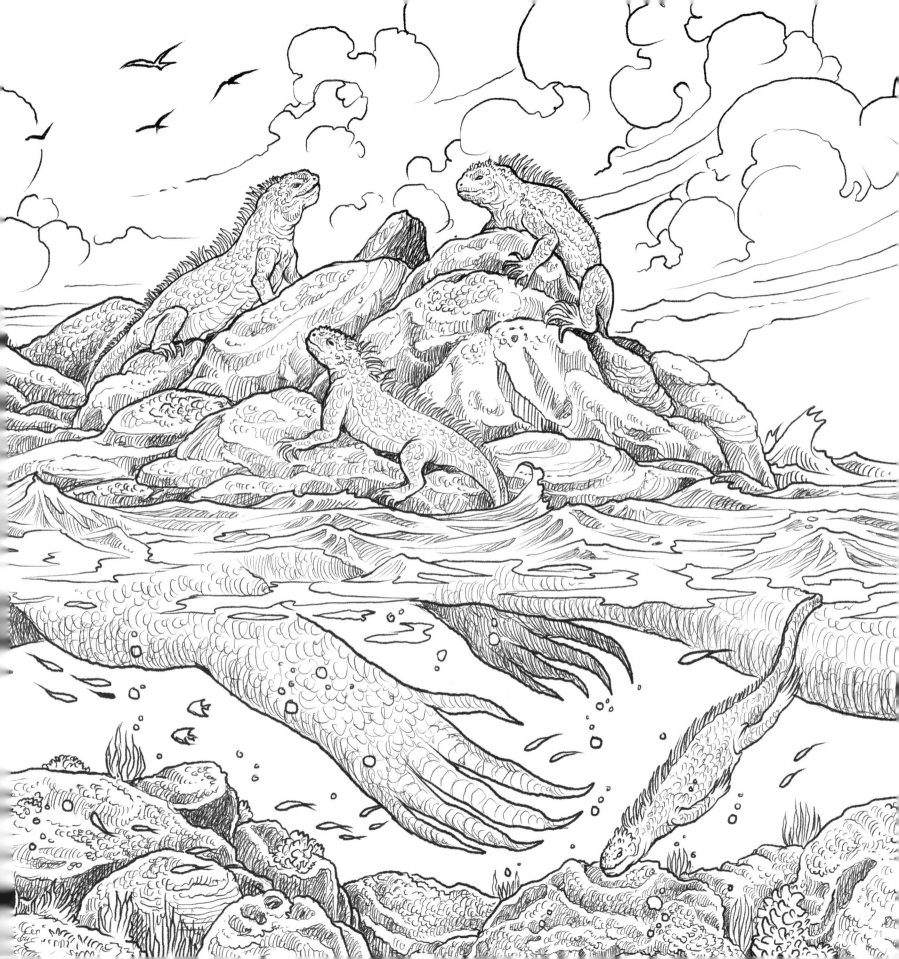

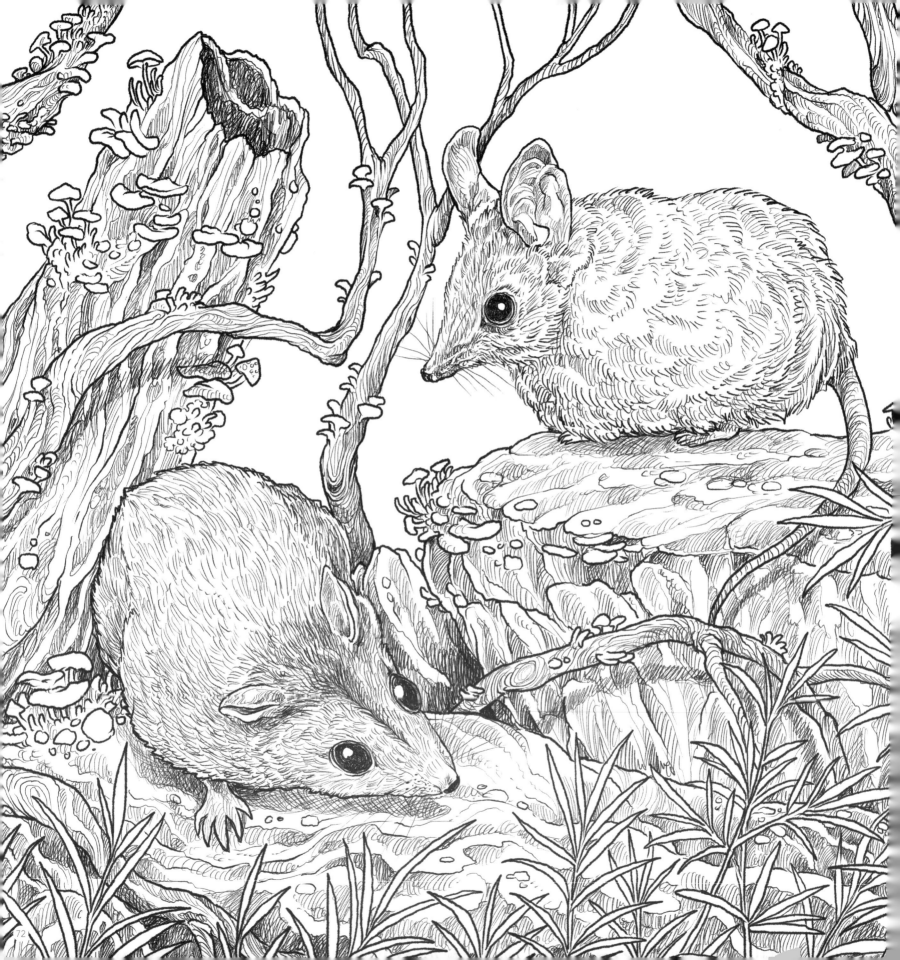

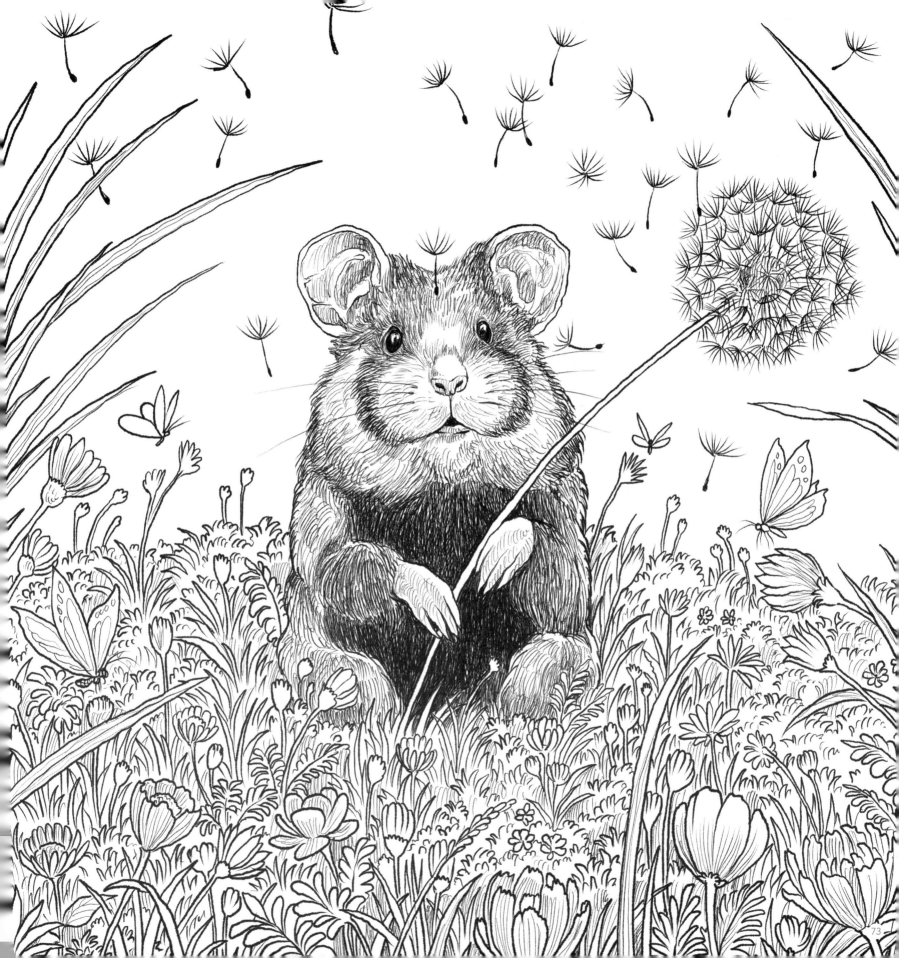

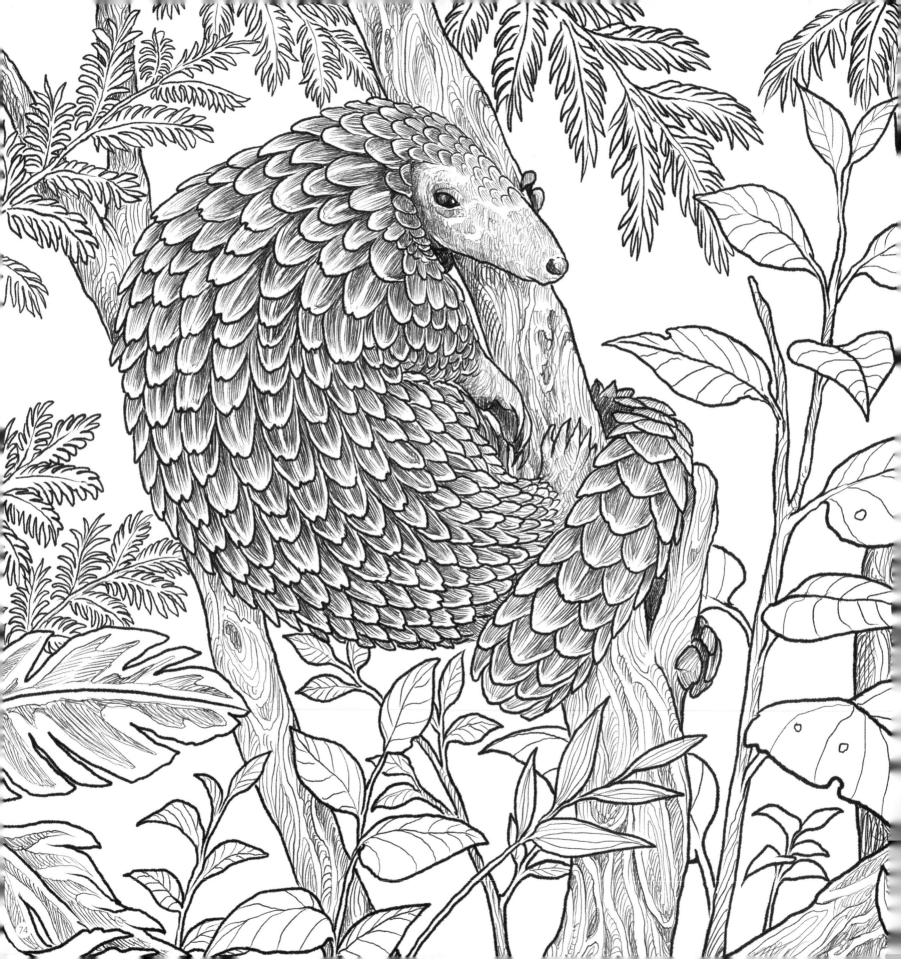

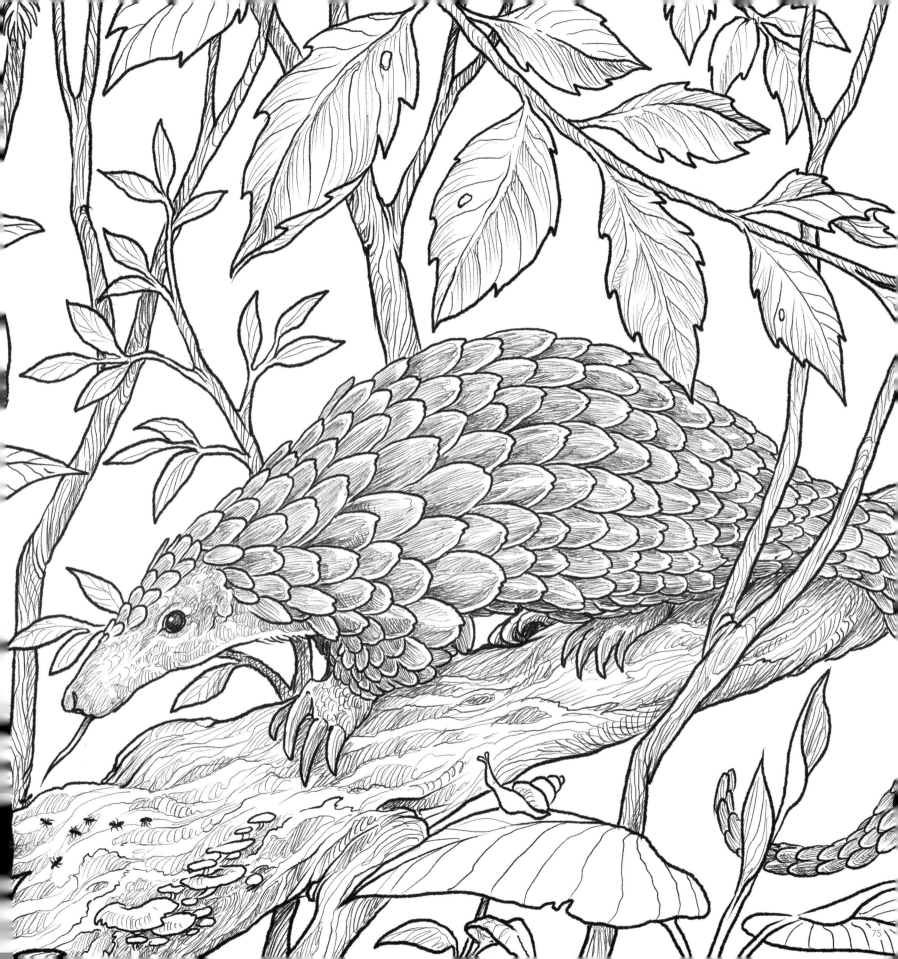

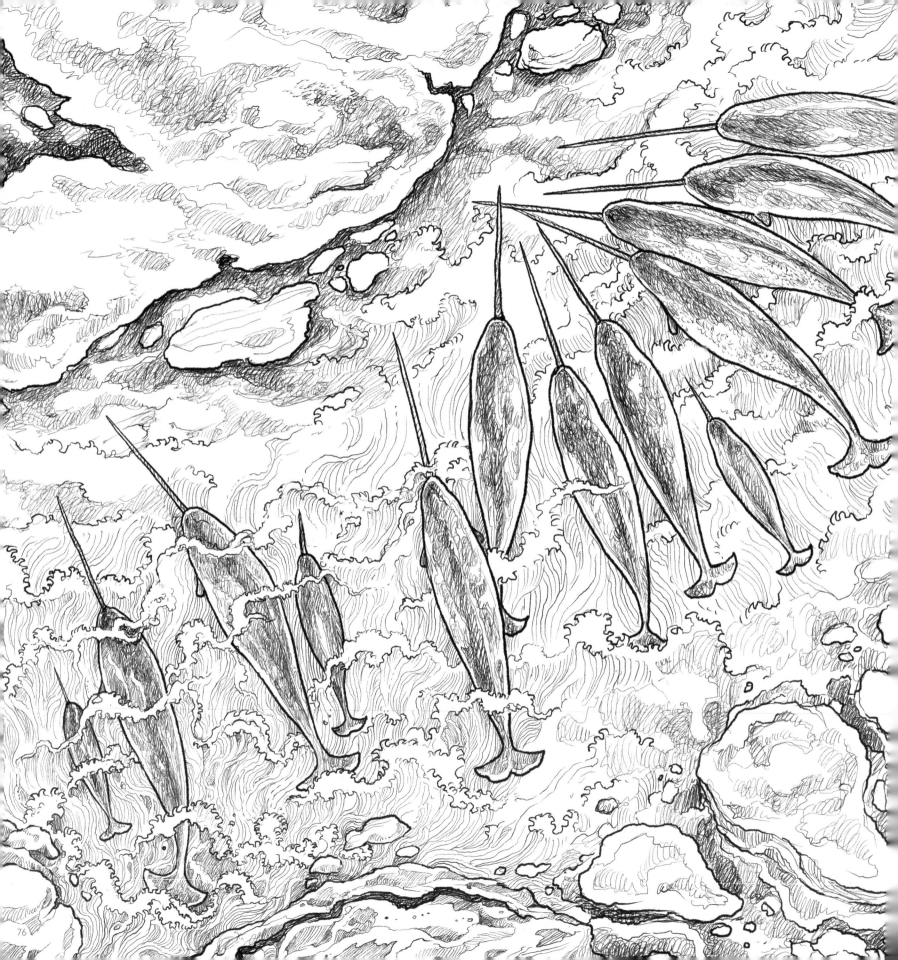

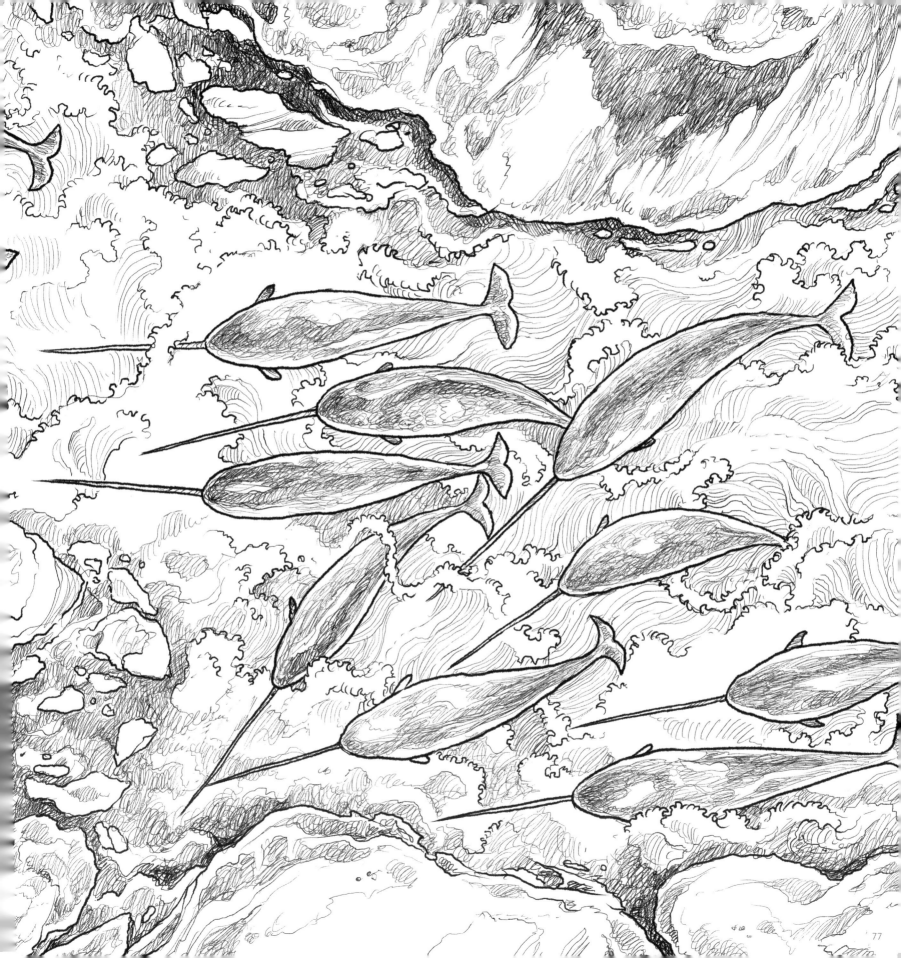

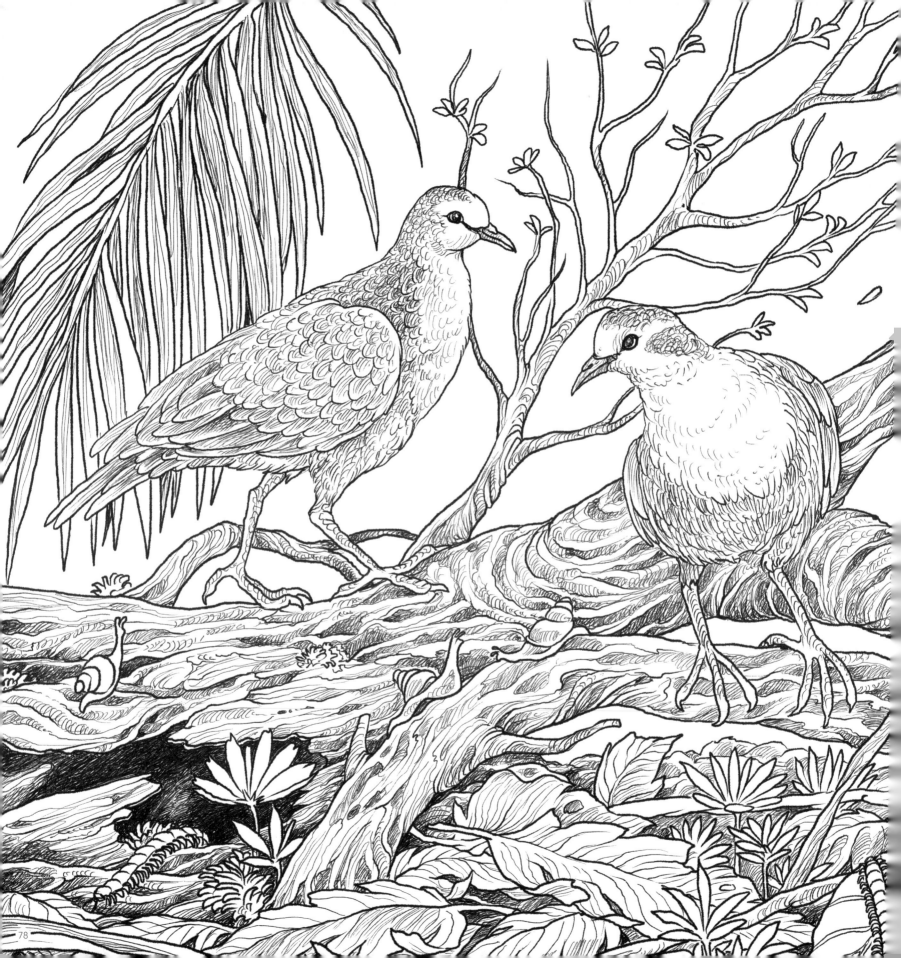

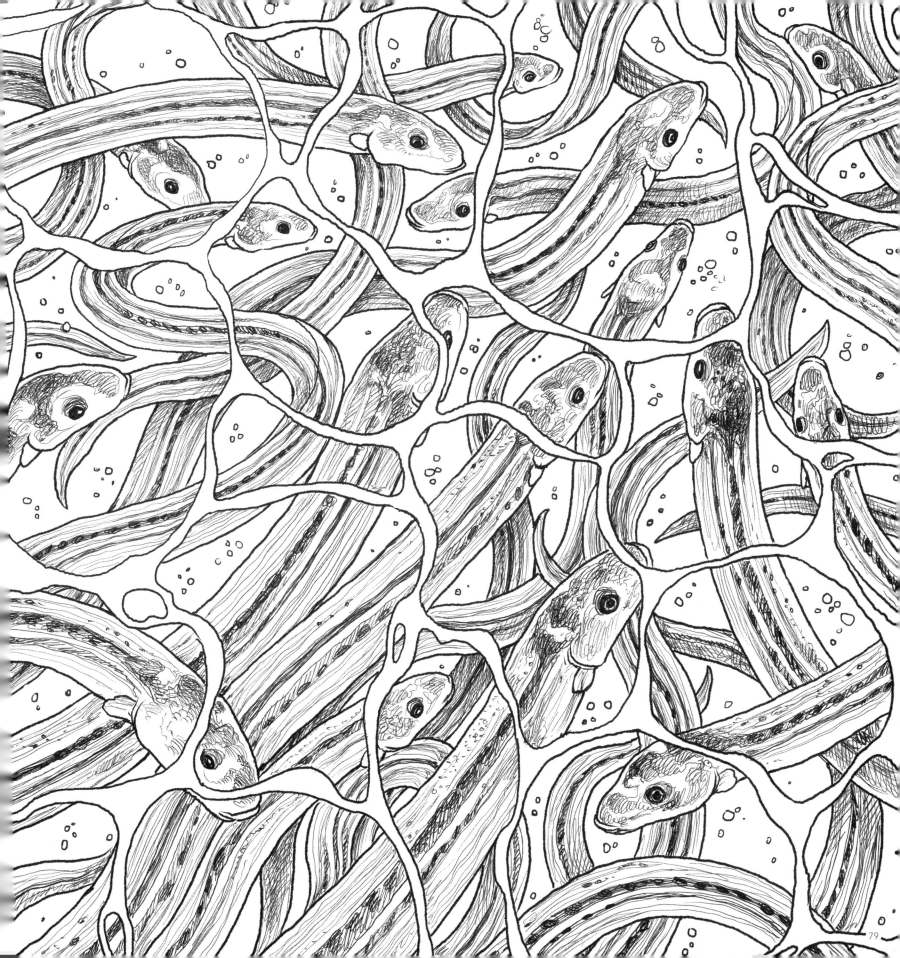

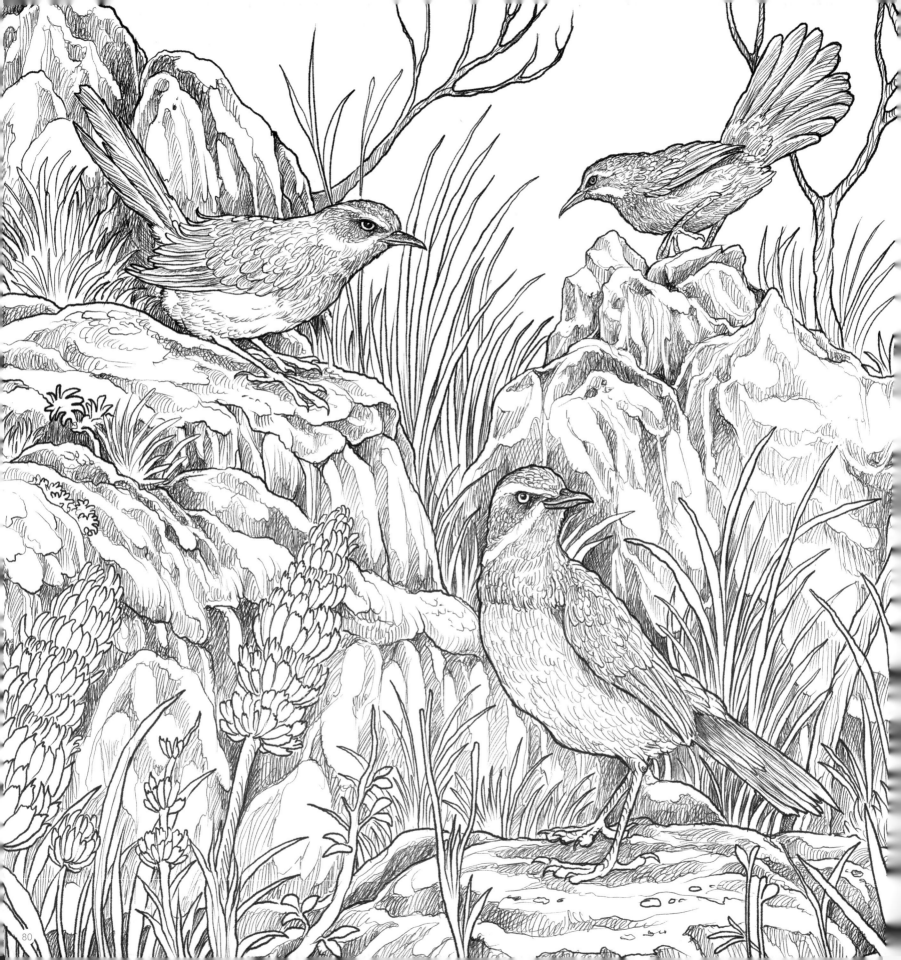

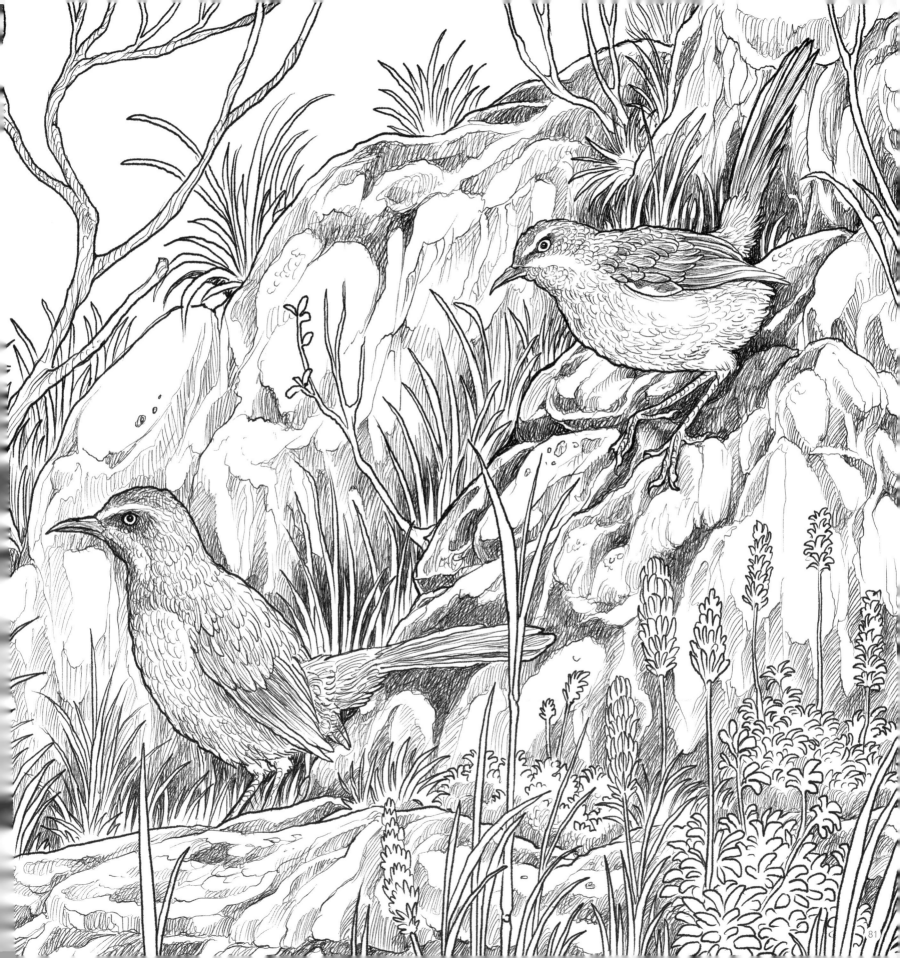

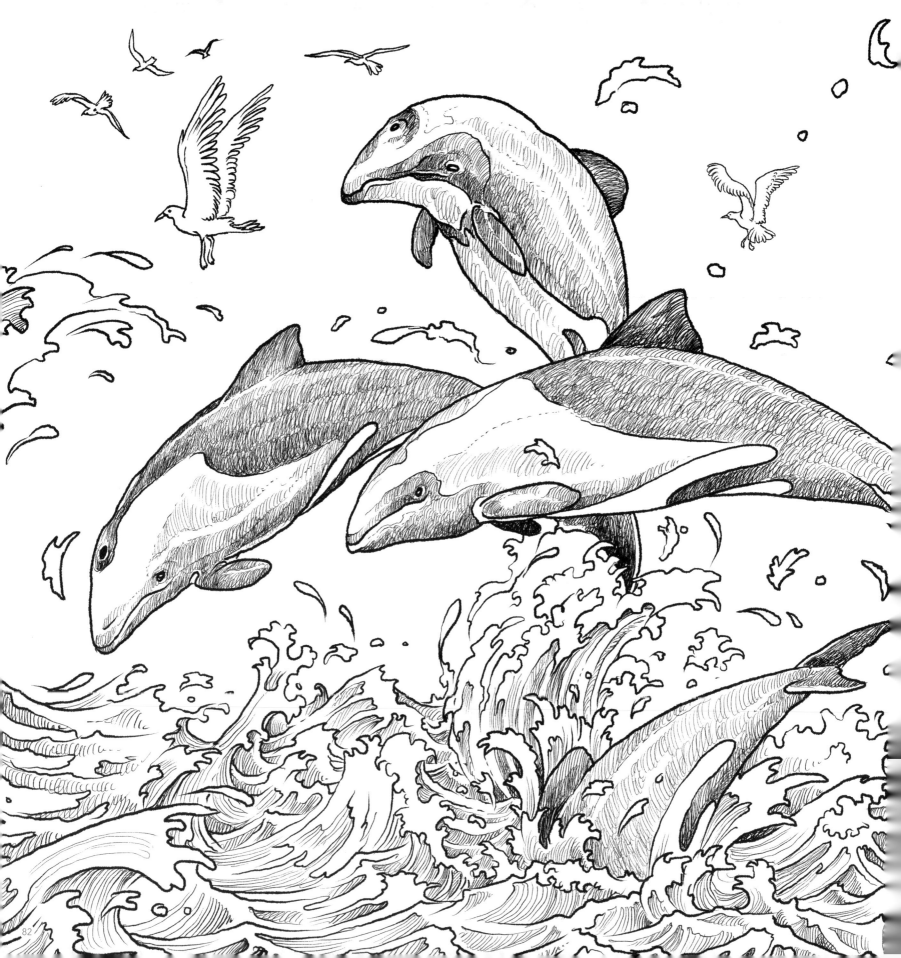

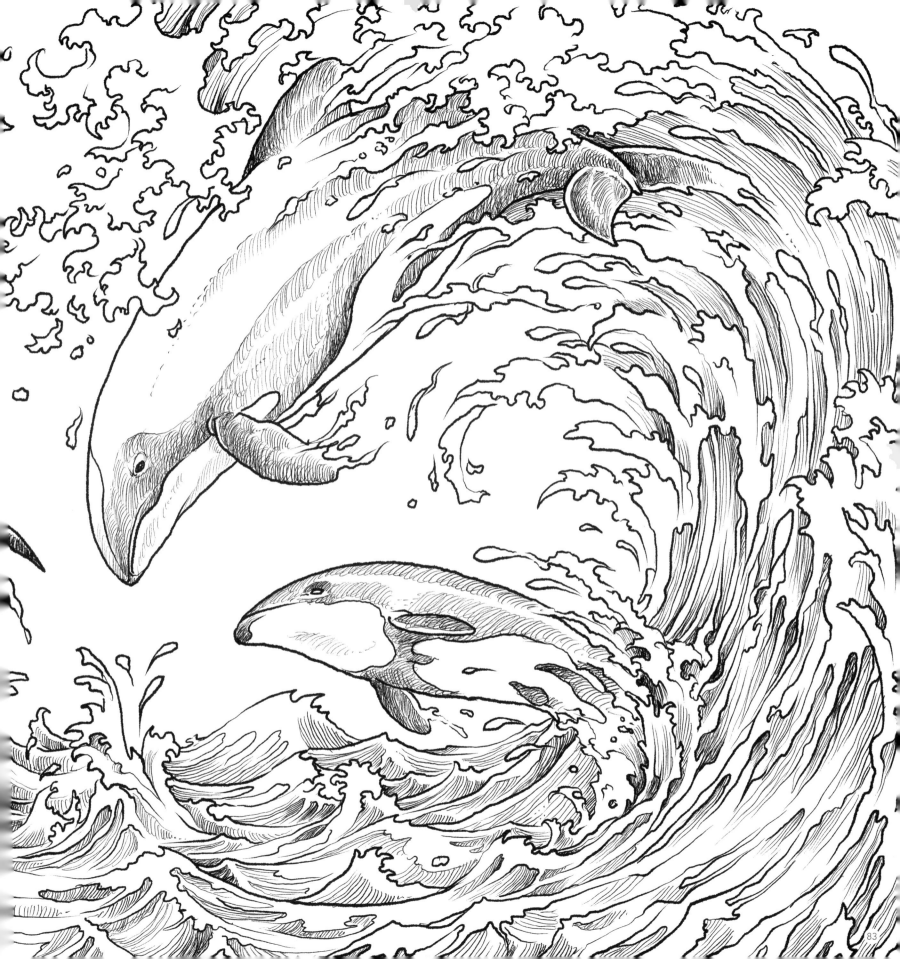

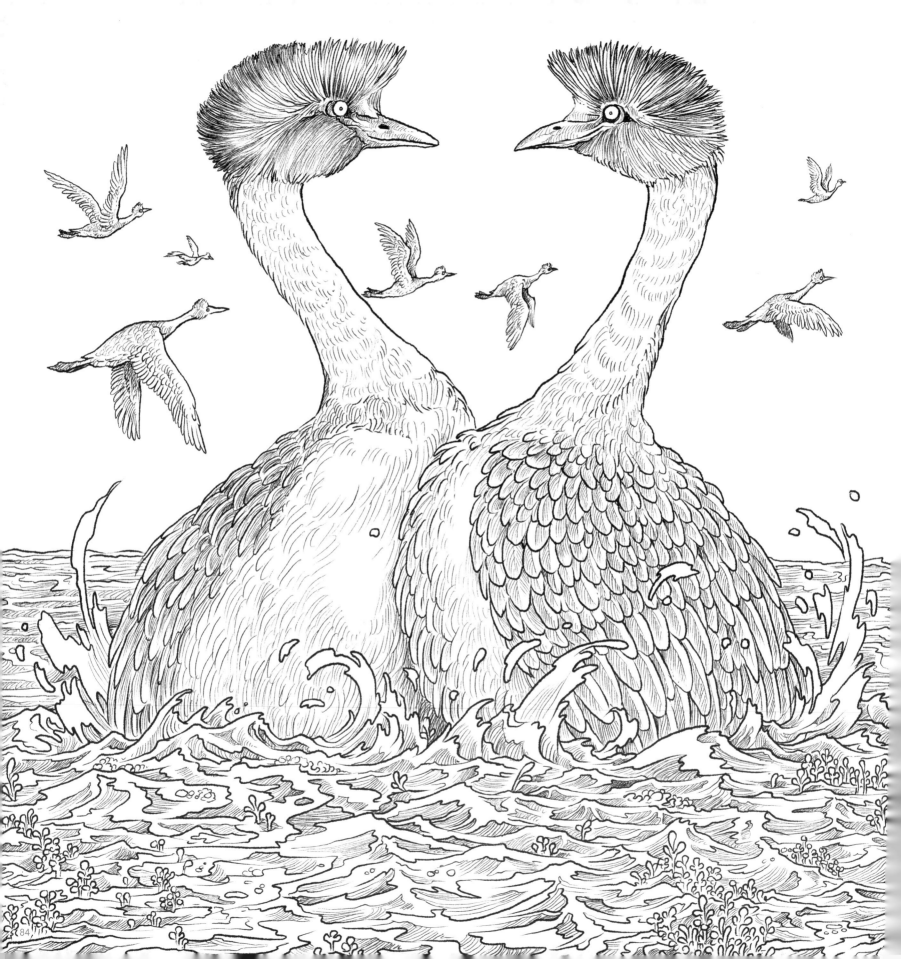

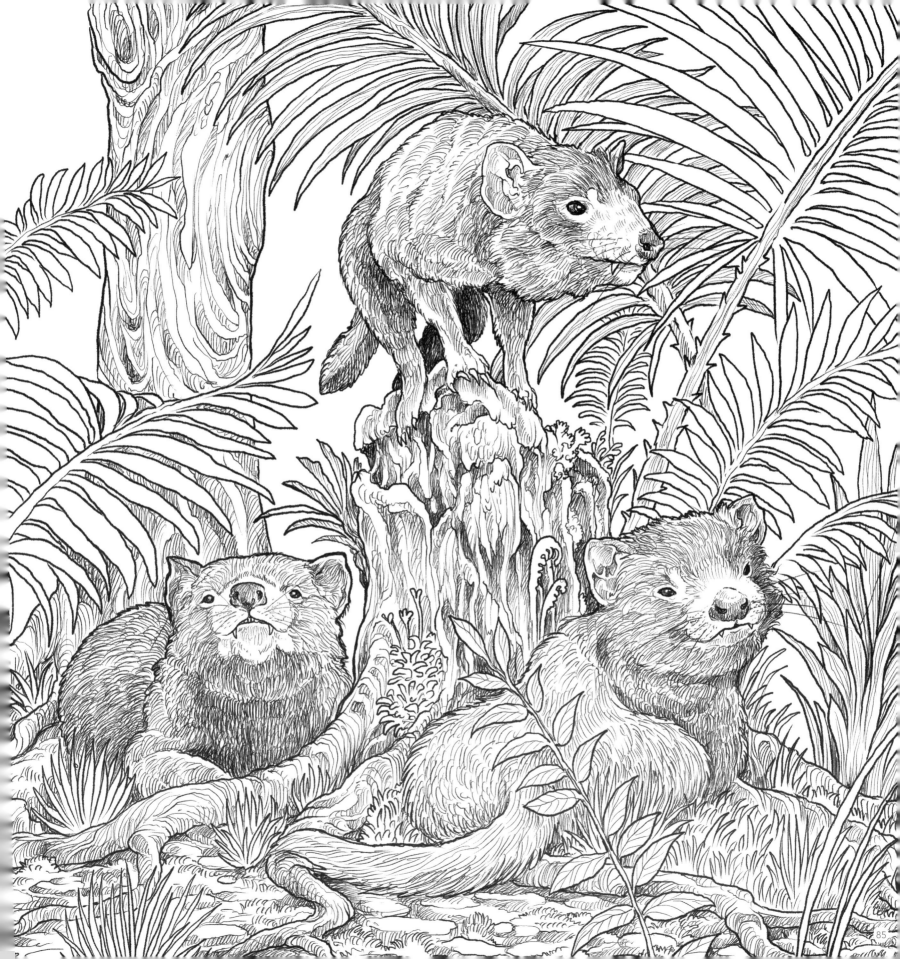

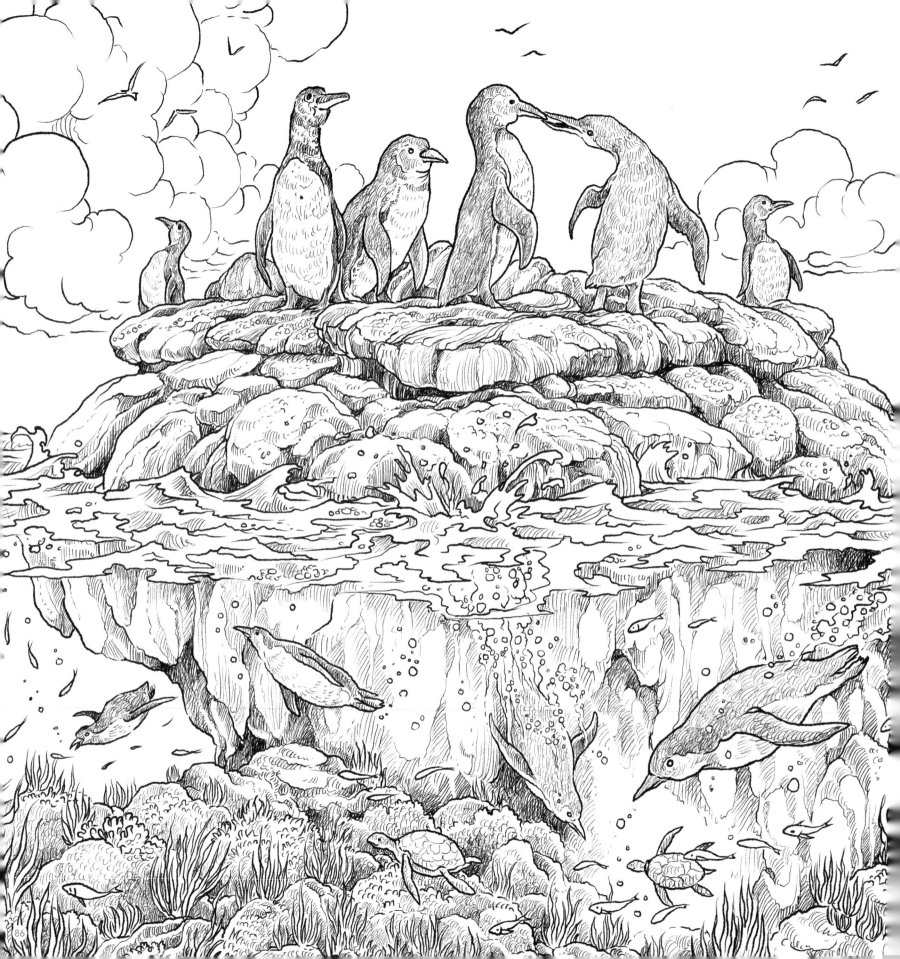

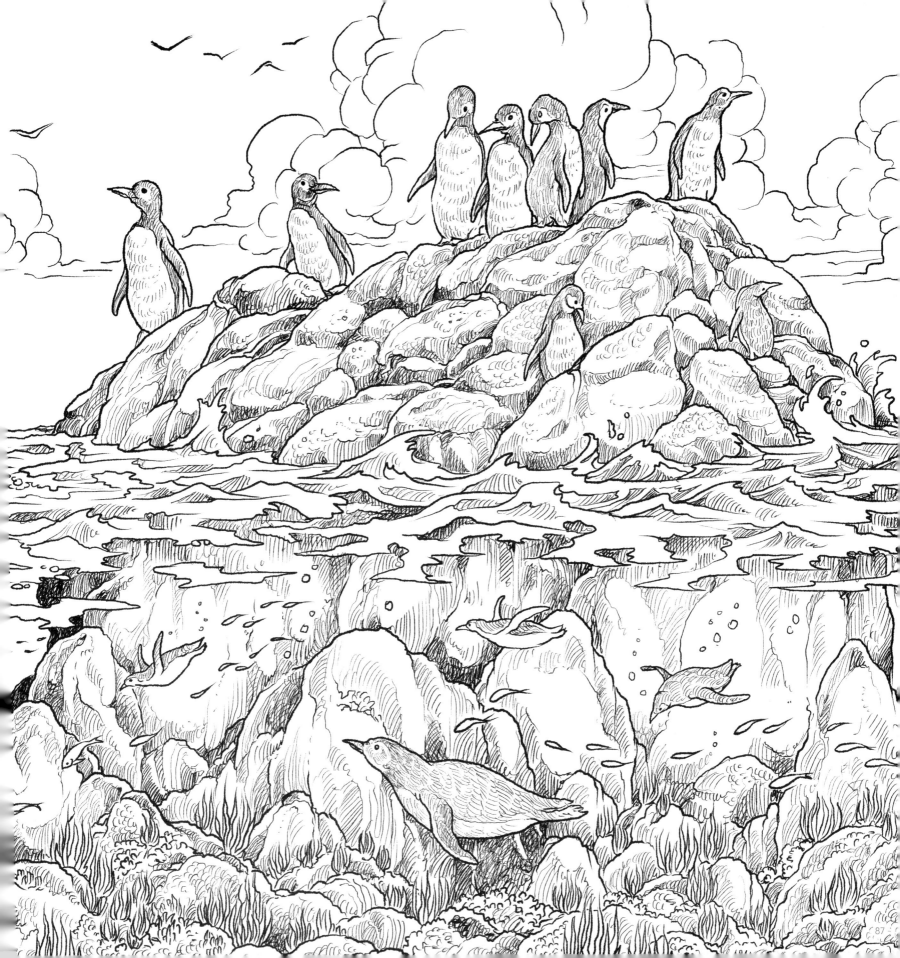

ABOUT THE ANIMALS

SNOW LEOPARDS—VULNERABLE (PP. 6–7)

Snow leopards are found throughout high mountain ranges in Central Asia. As snow leopards are top predators, without them the ecological balance would be disrupted. The main threat to their survival is the expansion of human settlement. Herders with livestock to protect kill snow leopards, but they are also poached for their fur and their use in traditional medicines. Climate change threatens the leopards' chances of survival, too—rising temperatures result in shrinking habitats and increased competition for food.

NEW ZEALAND LESSER SHORT-TAILED BATS—VULNERABLE (P. 8)

New Zealand lesser short-tailed bats are endemic to New Zealand and its offshore islands. At night, they forage on forest floors and by day they roost in colonies, primarily in old hollow trees. They are important pollinators of plants that grow on the forest floor. Their numbers are threatened due to forest clearance, which destroys the dead trees that the bats live in. Further threats include predators, such as rats and stoats, being introduced to their habitat. This has led to complete extinction of the species on certain islands.

MOUNTAIN GORILLAS—ENDANGERED (P. 9)

Mountain gorillas live in the forests of the mountains in Central Africa. There are estimated to be around 1,000 mountain gorillas alive today. Without these large herbivores eating vegetation, the natural balance in the food chain would be disrupted. Habitat loss, getting caught in traps meant for other animals, and even contact with human illnesses threaten their survival. Fortunately, their numbers have been increasing recently—while they were once listed as critically endangered, their status has now been changed to endangered. This shows that conservation efforts have been having a positive effect.

SOUTHERN ROCKHOPPER PENGUINS—VULNERABLE (P. 10)

Southern rockhopper penguins live on the rocky shorelines of the coasts north of Antarctica, from Chile to New Zealand. Despite being the world's smallest penguin, their feeding habits ensure that krill, small fish, and squid don't overpopulate the ocean. In the past, they were hunted and their eggs collected, but now pollution and overfishing are the biggest threats to these penguins. Their colonies on the Falkland Islands, in particular, have drastically decreased in size.

LEMUR LEAF FROGS—CRITICALLY ENDANGERED (P. 11)

Lemur leaf frogs are found in Costa Rica, Panama, and Colombia. These frogs are nocturnal animals with skin designed for camouflage, alternating between bright green in the day and reddish-brown at night. As predators and prey, they play an important role in the food chain, and even as tadpoles they help to keep water clean by feeding on algae. Their population has fallen by half in the last fifteen years due to habitat loss and a deadly fungal disease. However, a special breeding program is helping to reintroduce these frogs back into the wild and increase their numbers.

RING-TAILED LEMURS—ENDANGERED (PP. 12–13)

Ring-tailed lemurs are found only on the island of Madagascar and some of its small neighboring islands, off the coast of East Africa. These lemurs spend more time on the ground than other lemur species. It's here that they forage for fruit, the seeds of which are then spread throughout the forest in their droppings. Ring-tailed lemurs are under threat due to habitat loss—increased demand for farmland, charcoal production, and illegal logging are all causing the forests they live in to shrink.

SAIGA ANTELOPES—CRITICALLY ENDANGERED (P. 14)

Saiga antelopes, one of the most ancient mammals on the planet today, have existed since the time of the woolly mammoth. They are found in Kazakhstan, Russia, and Mongolia, and once also roamed parts of China before becoming extinct there. They are at great risk from poaching as their horns are sold for vast sums of money. Saiga travel in large herds, so it is easy to target many of them at once. Although they can breed rapidly to increase their numbers, it is the most successful breeding males who have the most-desired horns, meaning that poaching drastically alters their reproduction rates.

POLAR BEARS—VULNERABLE (P. 15)

Polar bears wander the Arctic, walking on ice sheets and swimming in coastal waters. At the top of the food chain, they help to maintain the health of their marine environment. Despite having no natural predators, polar bears are classified as vulnerable. Climate change is the greatest threat to their survival, with ongoing loss of their sea-ice habitat. The melting ice also increases human and polar bear contact, putting the bears at greater risk of being killed when searching for food in the summer months.

CHIMPANZEES—ENDANGERED (PP. 16–17)

Chimpanzees are found across Central and West Africa. They have a wide range of habitats, and although many live in tropical rainforests, they also occupy woodlands and grasslands. They benefit these habitats by spreading seeds from fruit, which are too big for most other animals to eat, in their feces. The main threat to their survival is habitat loss—humans are encroaching on their habitat to make space for logging, mining, oil extraction, and agriculture. This also results in a reduced wild food supply, meaning that some chimps will come into conflict with people when foraging for food in human territory.

AMERICAN BISON—NEAR THREATENED (PP. 18–19)

American bison inhabit North America, searching the plains for grasses, herbs, and shrubs. They aerate the soil while doing this, aiding plant growth and helping to maintain a balanced ecosystem. In the nineteenth century, around fifty million bison were killed for food, sport, and to deliberately deprive Native Americans of an important natural asset. This resulted in only a few hundred animals remaining. Now their numbers have increased, with conservation efforts under way across the country's vast grasslands.

QUEEN ALEXANDRA'S BIRDWING BUTTERFLIES—ENDANGERED (P. 20)

Queen Alexandra's birdwing butterflies live exclusively in Papua New Guinea. They are the largest butterflies in the world, with wingspans of up to twenty-eight centimeters. They are an important component of the food chain—the caterpillars eat foliage, and the nectar-feeding adults pollinate flowers. Among other things, habitat loss, due to commercial logging and the expanding oil palm industry, is threatening their survival. They are also highly valued by collectors, so illegal trading contributes to their diminishing numbers.

RUSTY PATCHED BUMBLEBEES—ENDANGERED (P. 21)

Rusty patched bumblebees once thrived across much of North America, but over the past twenty years the population has dropped by almost 90 percent. Most of this decline is due to lost habitat, which deprives the bees of nesting sites and prevents them from accessing nectar and pollen. Not only do the bees rely on the pollen from plants, but some plants also rely on the bees to pollinate them. However, work is being done to reintroduce these bees and to sustain some of their natural habitat.

GREAT WHITE SHARKS—VULNERABLE (PP. 22–23)

Found in cool, coastal waters around the world, great white sharks are the largest predatory fish on Earth. As "apex" predators, they control the number of other predatory fish and mammals, maintaining the balance in the food chain. Their numbers are decreasing due to a range of factors. Not only are they caught and sold as food, they are also prized as sport fish, and their teeth and jaws are sold for vast sums of money. They can also die when accidentally caught in fishing nets.

MANDRILLS—VULNERABLE (P. 24)

Mandrills are the largest of all monkey species, and can only be found in the rainforests of equatorial Africa. Although they are able to climb trees, and do sleep there, they spend most of their time foraging on the forest floor for fruits, insects, and small amphibians. They help to maintain the forest by dispersing seeds throughout their habitat. Their survival is at threat due to human interference—they are hunted as bushmeat and considered to be a delicacy. Increasing agriculture and human settlements has also resulted in deforestation, reducing their habitat.

PHILIPPINE EAGLES—CRITICALLY ENDANGERED (P. 25)

Philippine eagles, endemic to the Philippines, are one of the world's most powerful birds of prey. They are at the top of the food chain, where they play a crucial role in maintaining the balance of the ecosystem by regulating the populations of their prey, from bats and rodents to pigs and monitor lizards. They are threatened by fragmented habitat, agriculture, mining, and hunting, among other things. However, they are now the national bird of the Philippines, which has helped to raise awareness of these birds and their critically endangered status.

HUMPHEAD WRASSES—ENDANGERED (PP. 26–27)

Humphead wrasses swim through the coral reefs off the coasts of Asia and East Africa. They eat hard-shelled prey, such as mollusks and crustaceans, including the crown-of-thorns starfish, which is a predator of coral. Eating these starfish helps to maintain the health of the reefs. The main threat to humphead wrasses' survival is overfishing, as they are considered a luxury food. As a highly valued commodity, fishermen will often resort to poaching wrasses in ways that also damage the coral reefs.

BLACK-FOOTED FERRETS—ENDANGERED (PP. 28–29)

Black-footed ferrets are among the most endangered mammals of North America. Their diet consists mainly of prairie dogs, many colonies of which were eliminated toward the end of the 1900s because their burrowing activities damaged fields. As a result, almost the entire population of black-footed ferrets was wiped out. Since then, vast efforts have been made with breeding programs to increase their numbers. An estimated 300 black-footed ferrets now live in the wild.

GIANT PANDAS—VULNERABLE (PP. 30–31)

Giant pandas live in the remote, mountainous regions of Central China. As much as 98 percent of their diet consists of bamboo. Pandas play a crucial role in China's bamboo forests by spreading seeds in their droppings and helping the vegetation to grow. Despite their lack of natural predators, pandas are still at risk due to the severe threat from humans through habitat loss. Thanks to improved conservation efforts, the number of giant pandas in the wild is increasing, but they are still one of the rarest and most endangered bear species in the world.

COMMON HIPPOPOTAMUSES—VULNERABLE (P. 32)

Common hippopotamuses are native to more than thirty African countries. They spend up to sixteen hours a day in rivers and lakes, which helps to keep their bodies cool under the hot sun. They have adaptations to suit their semi-aquatic lifestyle, such as webbed toes, and their eyes, ears, and nostrils being high on their head so they can still see, hear, and breathe while almost completely submerged. Their populations are threatened by loss of habitat and hunting. When they come into conflict with humans, they can be killed, and they are also hunted for their fat and their ivory tusks.

PHILIPPINE NAKED-BACKED FRUIT BATS—CRITICALLY ENDANGERED (P. 33)

Philippine naked-backed fruit bats are a cave-roosting species endemic to the Philippines, found only on two of its islands, Cebu and Negros. By the 1970s, the species was believed to have gone extinct. However, small populations were found on each island in the early 2000s. The main threats to the bats' survival are overhunting, deforestation, and disturbance at their cave roosts. The animals' feeding and reproduction is disturbed when humans enter their caves to mine guano—the bats' feces, which is used as a fertilizer.

JAGUARS—NEAR THREATENED (PP. 34–35)

Jaguars live in the forests and grasslands of the Amazon in South America. They are the top predators in their environment, therefore controlling the populations of other species and balancing the food chain. As strong swimmers and climbers, they span large areas of the rainforest and riverbank. A combination of being hunted and habitat loss threatens the survival of jaguars. Deforestation has also led to fragmentation, meaning that the cats can get trapped in one area of land and are unable to travel to find food or a mate.

WHOOPING CRANES—ENDANGERED (PP. 36–37)

Whooping cranes have a very limited habitat, with a breeding ground in Canada and a yearly migration to Texas for the winter. Although they were once at great risk from hunting and egg collection, the biggest threat to their survival now is habitat loss. Living only in isolated wetlands means they are vulnerable to any changes in their environment. However, despite nearly going extinct in the 1940s, captive breeding programs have helped to boost their numbers in recent years.

ASIAN ELEPHANTS—ENDANGERED (P. 38)

Made up of three subspecies, Asian elephants inhabit forests and grasslands across South and Southeast Asia. These large mammals feed on grasses, bark, roots, and leaves, which helps to maintain the forest habitat they live in. However, their favorite foods are cultivated crops, such as bananas and sugarcane. The biggest threat to their survival is habitat loss and fragmentation—their territory is being reduced by expanding human development and their migratory routes are being blocked. With the reduction of their habitat comes increased human-elephant conflict and, despite global protection, poaching is still fueled by illegal wildlife trade of their ivory tusks, skin, tail hair, and meat.

FOREST OWLETS—ENDANGERED (P. 39)

Forest owlets live in central India and, unlike most other owls, they are active during the day. These small owls prey on lizards and amphibians, as well as small birds and rodents, helping to maintain their ecosystem. Due to conservation efforts, there are some areas that have a good wild population of forest owlets. However, continued habitat fragmentation through illegal logging and expanding agriculture will pose a threat to this endangered species.

GHARIALS—CRITICALLY ENDANGERED (PP. 40-41)

Gharials are a type of Asian crocodilian. They live in freshwater river systems, congregating at river bends, where the water is at its deepest. As top predators in their habitat, gharials help to maintain river ecosystems. Sadly, they are only found in two countries now: India and Nepal. The threat to their survival is human activity. Overfishing leaves them with less food to eat and at risk of being caught in nets, but they're also hunted for use in traditional medicine. Furthermore, the courses of the rivers they live in are being manipulated for agricultural use, reducing the water levels that they need to survive.

GALÁPAGOS SEA LIONS—ENDANGERED (PP. 42-43)

Galápagos sea lions dwell in large colonies on the rocks and sandy shores of the Galápagos Islands, as well as Isla de la Plata, an island off Ecuador. They hunt a variety of fish that can be found close to shore, as venturing farther afield puts them at risk of being eaten by sharks and whales. El Niño—a complex weather system that results in changing ocean temperatures—is their biggest threat, as it drastically reduces the amount of food they can access. Introduced species, such as dogs and cats, carry diseases that can spread to sea lions, and they are also at risk of getting caught in fishing nets.

SUMATRAN TIGERS—CRITICALLY ENDANGERED (P. 44)

Sumatran tigers are native to the Indonesian island of Sumatra. Despite being the smallest subspecies of tiger, they are still top predators at the apex of the food chain. Habitat loss and poaching are two of the biggest threats to these critically endangered tigers. The expansion of oil palm plantations caused an almost 20 percent loss in their habitat between 2000 and 2012. Palm oil can be found in everything from pizza dough to lipstick, and oil palm plantations are devastating the natural habitats of many wild animals.

BLACK RHINOCEROSES—CRITICALLY ENDANGERED (P. 45)

Black rhinoceroses live in southern and eastern Africa. They are generally solitary and feed at night or during dawn and dusk, when they can escape the African sun. They mostly eat from trees and bushes, unlike their counterpart, the white rhinoceros, which grazes on grasses. Today, these magnificent creatures are on the brink of extinction due to poaching—their horns are desired by many for traditional medicine and ornamental dagger handles.

THICK-BILLED PARROTS—ENDANGERED (PP. 46-47)

Thick-billed parrots live in the pine forests of northern Mexico. They mainly eat pine seeds, as well as berries, fruit, and insects. Threats to their survival include deforestation in their native habitat, hunting, and their illegal capture for the pet trade. Experts think that climate change is increasing the number of parasitic fly larvae that feed on their chicks and can kill them.

HAWKSBILL TURTLES—CRITICALLY ENDANGERED (P. 48)

Hawksbill turtles can be found primarily in shallow, tropical waters, usually among coral reefs. They cruise the coastlines, where it is easier to reach their nesting sites and to find food, such as sponges, mollusks, and jellyfish. Their diet plays a vital role in maintaining the health of coral reefs. Their critically endangered status is mostly due to human impact—their eggs are eaten, they can get caught in fishing nets, their shells are traded illegally, and their habitat is being eroded. Despite the many conservation agreements and laws that have been put in place to protect them, they remain critically endangered.

WHALE SHARKS—ENDANGERED (P. 49)

Whale sharks are found in the world's tropical oceans. They are the largest fish alive today and travel huge distances to find enough plankton to feed on to sustain their size. Their meat, fins, and oil are highly valued, and overhunting remains a threat to the population of this species. They can also get caught in fishing nets, and whale shark tourism can interrupt their feeding, while boat propellers might injure them.

ETHIOPIAN WOLVES—ENDANGERED (PP. 50–51)

Ethiopian wolves are endemic to Ethiopia but now live in just seven isolated areas in the country's highlands. They keep the populations in their habitat in check by preying on various small mammals, such as hares and giant mole rats. Humans pose the largest threat to these wolves, as agriculture is expanding and taking over their already limited habitats. Diseases, such as rabies, are also being introduced to their populations from domestic dogs.

AXOLOTLS—CRITICALLY ENDANGERED (PP. 52–53)

Axolotls live exclusively in the lakes of Xochimilco, near Mexico City. Although they may occasionally emerge from the water, they mostly stay on the beds of the lakes and canals they live in. Once top predators in their habitat, the introduction of large fish into their lakes has increased their natural threats. Human interference has resulted in the draining and contamination of water in the Xochimilco lakes. Axolotls are also in high demand in the aquarium trade, further diminishing their numbers.

TAPANULI ORANGUTANS—CRITICALLY ENDANGERED (P. 54)

Tapanuli orangutans were officially announced as a new species of ape in 2017. There are fewer than 800 of them in the wild, making them the rarest of all great apes. They live in North Sumatra and studies have shown they are both genetically and behaviorally different from the other two species of orangutans—Bornean and Sumatran. They are known as "gardeners of the forest" and play a vital role in seed dispersal. These great apes are under severe threat caused by human encroachment and deforestation, and a planned hydroelectric dam project could destroy what remaining habitat they have.

KOALAS—VULNERABLE (P. 55)

Koalas live in the eucalyptus forests of southeastern and eastern Australia. The eucalyptus trees provide them with both habitat and food. They can eat half a kilogram of eucalyptus leaves every day. The koala population plummeted in the early years of the 1900s due to hunting for their fur. However, they are currently under threat from severe habitat loss, as much of the forest they live in has been destroyed by bushfires, land clearing, and logging.

BLUE WHALES—ENDANGERED (PP. 56–57)

Blue whales are the largest animals ever known to have existed on Earth. They live across all the world's oceans, except the Arctic, undertaking lengthy migrations each year. They are important in managing the health of the marine environment. Aggressive hunting between the 1900s and 1960s resulted in near extinction, but a new protection law in 1966 managed to save a small number. Although they have few predators, many blue whales can be injured or die from collisions with large ships.

AMUR LEOPARDS—CRITICALLY ENDANGERED (P. 58)

Amur leopards live in the temperate forests in the far east of Russia, experiencing cold, snowy winters and hot summers. They are the top predators in their habitat and help to maintain the right balance of species. Amur leopards are poached for their fur, but another threat they face is the scarcity of their prey. As their habitat is surrounded by agriculture and villages, their prey is often hunted by humans, reducing their access to food.

RED PANDAS—ENDANGERED (P. 59)

Red pandas live in high-altitude forest habitats across the mountains of Nepal, Myanmar, and Central China. They are solitary animals that spend most of their time in trees, helping to maintain the bamboo plants in the forests they live in. Their endangered status is primarily due to the deforestation of their natural habitats through logging and increased agriculture. They are also poached for their fur, and can be accidentally killed in traps meant for other wild animals.

ADDAXES—CRITICALLY ENDANGERED (PP. 60–61)

Addaxes are a species of antelope found in the Sahara Desert in Africa. These animals almost became extinct in the wild at the end of the twentieth century due to uncontrolled hunting, and there are now thought to be fewer than 100 left in the wild. There are several hundred living in zoos and private ranches, but reintroduction to the wild relies on better protection for these animals, which are still overhunted. Effective protection is currently not possible due to the vast and remote areas they inhabit.

DUGONGS—VULNERABLE (PP. 62–63)

Dugongs live in the shallow waters on the edges of the Indian and the Pacific Oceans and the Red Sea. They graze on seagrasses, which encourages regrowth and in turn ensures a healthy habitat and feeding ground for other marine species. They are threatened by habitat loss and degradation to the seagrass, which is mainly due to coastal development and activities that cause water pollution. The conservation of the dugongs' shallow water habitat is vital to secure their survival.

GREATER SAGE-GROUSE—NEAR THREATENED (PP. 64–65)

Greater sage-grouse are found in western parts of North America and parts of Canada. Their presence indicates a healthy sagebrush habitat, which is in turn able to support other animals, such as pronghorn antelopes and songbirds. Their status is near threatened because of a number of factors, such as expanding agriculture and climate change. Oil and gas development can also disrupt the landscape and inhibit their ability to reproduce. Loud sounds from the energy towers can drown out the calls the grouse make when looking for mates.

AMERICAN BURYING BEETLES—CRITICALLY ENDANGERED (P. 66)

American burying beetles are found across the savannahs and grasslands of Midwestern America and Texas. These beetles play an important role in the ecosystems they inhabit by breaking down dead animals. This not only provides them and their offspring with food but also returns nutrients to the soil. They are very unusual among insects in that the parents feed and take care of their larvae. Habitat loss is thought to be the greatest cause of their decline, as it means they struggle to find food. Increased use of pesticides may also play a part in their diminishing numbers.

SEA OTTERS—ENDANGERED (P. 67)

Sea otters live along the coasts of the Pacific Ocean in North America and Asia. They play an important role in maintaining the health of kelp forests by eating sea urchins. The kelp forests provide homes for many animals, but sea urchins are destructive to these plants. At one time, sea otters were hunted to near extinction for their fur. Today, they are protected by law, but their status remains endangered. Scientists predict that populations will continue to decrease as a result of oil pollution and habitat loss.

AFRICAN WILD DOGS—ENDANGERED (PP. 68–69)

African wild dogs mostly live in southern Africa and southern East Africa, although they can be found in other regions of Africa, too. They are opportunistic predators that will often hunt sick or weak animals. This helps to maintain a natural balance and also improves the overall health of prey populations. Habitat loss is the main threat to these dogs—with smaller hunting ranges, they more frequently come into contact with larger predators and with humans, which can result in both targeted and accidental killing.

MARINE IGUANAS—VULNERABLE (PP. 70–71)

Marine iguanas inhabit the Galápagos Islands and are the world's only oceangoing lizard. Although they might look fierce, these reptiles are herbivores that graze on algae and seaweed. Scientists are unsure of their population, but they are under threat from introduced predators, such as rats, cats, and dogs that feed on their eggs and young. The impacts of climate change are also a threat as the iguanas struggle to adapt to the changing sea level and air temperature. However, their nesting beaches are now being protected to try to encourage the growth of their population.

KANGAROO ISLAND DUNNARTS—CRITICALLY ENDANGERED (P. 72)

Kangaroo Island dunnarts are found exclusively on Kangaroo Island in Australia. In the past, the primary threat to these animals was the clearing of their native habitat for agricultural purposes. However, the 2020 bushfires destroyed 95 percent of their remaining habitat, and there are now thought to be around only fifty Kangaroo Island dunnarts remaining in the wild.

EUROPEAN HAMSTERS—CRITICALLY ENDANGERED (P. 73)

European hamsters are found across Europe and Asia. They are an important part of the food chain, serving as prey for a range of animals, from the European red fox to large birds. Climate change, agriculture, and light pollution have all contributed to their decline, and scientists predict that they could become extinct within the next three decades.

CHINESE PANGOLINS—CRITICALLY ENDANGERED (PP. 74–75)

Chinese pangolins are found in forests and grasslands in China. These animals eat ants and termites, meaning that they contribute to pest control and improve soil quality. They have been poached for their meat and scales for many years, as their meat is considered a delicacy and their scales are used in traditional medicine. As a result, these mammals are now critically endangered. In 2020, China increased protection of the Chinese pangolin to the highest level and it is hoped this will have a positive effect on their population.

NARWHALS—NEAR THREATENED (PP. 76–77)

Narwhals live in the coastal waters and rivers of the Arctic. They are at the top of the food chain and play an important role in the health of the environment they live in. Narwhals depend on sea ice, both as a place of refuge and a place to feed. They spend up to five months of the year underneath the ice during winter, and as such they are directly impacted by climate change. Ocean noise and pollution is also thought to put them at risk, as noise can interfere with their echolocation. Although they are not yet endangered, their survival is at threat due to their changing habitat.

POLYNESIAN GROUND DOVES—CRITICALLY ENDANGERED (P. 78)

Polynesian ground doves, also known as tutururus, are found on just five small islands in French Polynesia. There are estimated to be around 150 of them left in the world. Despite living in such a remote location, they have not escaped the toll of human interference, as the introduction of predatory mammals, such as rats and cats, has disturbed their habitat and ecosystem.

EUROPEAN EELS—CRITICALLY ENDANGERED (P. 79)

European eels can be found in a large range of freshwater and marine locations, from Europe and Russia to northern Egypt. Spending much of their adult life in freshwater rivers and streams, they venture back to the ocean to lay their eggs. These eels feed at night and they will eat anything from fish and crustaceans to insects and worms. During the day, they burrow down into the mud. Some estimates suggest their population has shrunk to fewer than 1 percent of historic levels, but scientists have been unable to define a singular, major threat. Likely causes include blocked migratory routes, climate change, and pollution.

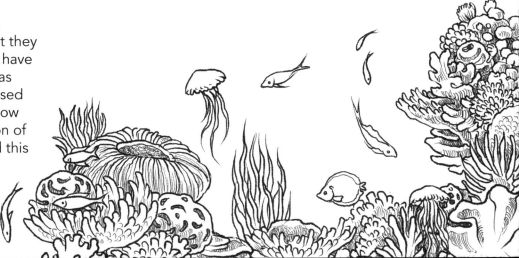

CAPE ROCKJUMPERS—NEAR THREATENED (PP. 80–81)

Cape rockjumpers are found in "fynbos," an area of natural shrubland around the Western and Eastern Cape provinces of South Africa. Their numbers are falling and, although the specific reasons for this are unknown, it is likely to be related to climate change. The warming climate is reducing their fynbos habitat. The increasing temperatures can also affect the amount of water they need and their feeding habits.

HECTOR'S DOLPHINS—ENDANGERED (PP. 82–83)

Hector's dolphins live in the shallow coastal waters of New Zealand's North Island. They are the smallest and rarest marine dolphins in the world. They are at the top of the food chain and regulate fish populations in their habitat. The fact that they only live in one location, and close to the shore, means they are at a greater risk of being struck by boats and of being accidentally caught in fishing nets as "bycatch." They are also affected by pollution and coastal development.

HOODED GREBES—CRITICALLY ENDANGERED (P. 84)

Hooded grebes are found in regions of Argentina. There are thought to be around only 1,000 of them left in the wild. However, their population is now considered stable because of the conservation efforts to help them survive. Their main threat is climate change, which affects the water levels in the lakes where they feed and breed. The American mink also preys on hooded grebes and can kill many in a single day, but efforts to control the number of mink has helped to stabilize the population of these birds.

TASMANIAN DEVILS—ENDANGERED (P. 85)

Tasmanian devils used to live all over Australia but now survive only on the island state of Tasmania. As they prefer to scavenge rather than hunt, they often eat dead animals, which helps their habitat as they will clear up almost any carrion that is lying around. In the late 1800s, great efforts were made to eradicate Tasmanian devils as they were believed to be killing livestock. They have since been given legal protection, which has helped their numbers, although a rapidly spreading and contagious cancer has since caused the deaths of more than 100,000 of these marsupials.

GALÁPAGOS PENGUINS—ENDANGERED (PP. 86–87)

Galápagos penguins are the only penguin species that is found north of the equator. There are thought to be fewer than 2,000 of these animals left in the wild. They are threatened by pollution in the sea, getting caught in fishing nets, and by climate change. As well as this, there are a number of species that have been introduced to their habitat, such as dogs, cats, and rats, that spread disease and act as predators.